W9-BQY-411

PRINCIPLES OF CHINESE PAINTING

PRINCETON MONOGRAPHS
IN ART AND ARCHAEOLOGY
XXIV

PRINCIPLES OF
CHINESE PAINTING

By GEORGE ROWLEY

PRINCETON, NEW JERSEY

PRINCETON UNIVERSITY PRESS

Printed in the United States of America
by Princeton University Press, Princeton, New Jersey

To Marion my wife

PREFACE

This book is an attempt to formulate the Chinese cultural traits and to analyze their expression in pictorial principles. Because it has been impossible to find satisfactory English equivalents for the Chinese terms, transliterations of the main terms have been inserted into the text for greater accuracy. It has also been difficult to select a single term for a specific pictorial idea because the terms themselves have been reinterpreted in different periods and because the Chinese writers have not been consistent in their use. It is illuminating to note that Chinese terminology has been rich in dealing with the nature of art and very limited in describing principles of design, probably because the latter were handed down as the accepted rules without the need for formulation into conceptual terms. To us the notions of unity, coherence and emphasis are basic in any composition, but the Chinese tend to describe each process instead of defining them by single terms (see List of Terms).

The handling of the Chinese cultural orientations has been equally troublesome. Comparisons with western attitudes are apt to be more misleading than helpful, and yet the Chinese approaches to experience defy our understanding unless we relate them to western orientations. In discussing each cultural attitude, the device has been adopted of establishing two western polarities between which the Chinese have functioned. Only in this way can we avoid the pitfalls of interpreting the Chinese spirit in terms of western idealism, naturalism, subjectivism, romanticism or modernism. For example, because Chinese painting and "modern" painting are both more intuitive, abstract and suggestive than western painting has been since the Middle Ages, it does not follow that these superficial similarities stem from similar motivations. Chinese intuition is far removed from contemporary subjectivism; the abstract quality of Chinese design arose from simplification and elimination rather than from mechanization or distortion of forms; and suggestion in Chinese painting, although used to heighten the awareness of the unknown, seldom departs from the laws of nature. Today our painters strain after the new and the startling, while the Chinese artists built upon the old and the mature. If we look at Chinese painting through "modern" eyes we will miss its meaning. It should be our constant endeavor to escape from ourselves and from our machine-minded and psychologically intense age. Only then will we reach the inner harmony of the Chinese spirit which has revealed itself so supremely in Chinese painting.

The first edition was illustrated from the collection of Dr. DuBois S. Morris, generously presented to Princeton University in celebration of its Bicentennial. Obviously, no single collection, whether public or private, is comprehensive enough to illustrate the scope of this text. Therefore, examples for the second edition have been selected from many sources. These paintings have been chosen for their quality, appropriateness of subject matter, and coverage of all periods of Chinese painting from Han to modern times.

GEORGE ROWLEY

Princeton University, 1959

CONTENTS

PREFACE ix

LIST OF ILLUSTRATIONS xiii

SUBJECT MATTER AND ITS INTERPRETATION 3

 Introduction 3

 Spirit and Matter 5

 Heaven and Earth 9

 Divine and Human 11

 Taoism and Confucianism 13

 Personal and Impersonal 15

 Moods and Emotions 17

 Man and Nature 20

 Tradition and Originality 24

 Idealism and Naturalism 29

STYLE 33

 Introduction 33

 Ch'i or Spirit and its Fruits 34

 K'ai-ho or the Unity of Coherence 48

 Yin-yang or the Unity of Opposites 50

 The Unity of Consonance 52

 Chang-fa or Composition 54

 The Equilibrium of Tensions 59

 Sequence and Moving Focus 61

 Design in Depth and Ch'i-fu 64

Scale 66

Surface Design and Lung-mo 68

K'ung or Voids 71

Design and Decoration 74

Simplicity, Emptiness and Suggestion 77

CATEGORIES OF GREATNESS 79

LIST OF TERMS 81

LIST OF SOURCES 82

INDEX 83

ILLUSTRATIONS

ILLUSTRATIONS

1. Anonymous, Scenes of Filial Piety. Dated A.D. 145.

2. Anonymous, Loyalty of the Charioteer.

3. Anonymous, Gods of Storm and Great Dipper.
 Rubbings of Wu Liang-Tzŭ. Author's Collection, Princeton.

4. Copy of Ku K'ai-chih, Ladies at their Toilet. T'ang (?).

5. Copy of Ku K'ai-chih, Lady Fêng Rescuing Emperor Yüan from a Bear.
 Sections of the Admonitions hand-scroll. British Museum.

6. Chou Chi-ch'ang, Lohans Bestowing Alms. Dated A.D. 1178.
 Museum of Fine Arts, Boston.

7. Attributed to Wang Wei, Portrait of Fu Shēng. Early Sung.
 Abe Collection, Municipal Museum, Osaka.

8. Copy of Chou Fang, Listening to Music. Early Sung (?).
 Formerly Lo Chên-yü Collection.
 Reproduced from Tōsō Gemmin Meiga Taikan, Vol. I, Plate 2.

9. Liang K'ai, The Sixth Ch'an Patriarch Chopping Bamboo. Early 13th c.
 National Museum, Tokyo.

10. Liang K'ai, Portrait of Li T'ai-po. Early 13th c.
 National Commission for the Protection of Cultural Properties, Tokyo.

11. Jēn Jēn-fa, Scholars and the Arts. Late 13th c.
 Formerly Marquis Ōmura Sumihide Collection, Tokyo.
 Reproduced from Tōsō Gemmin Meiga Taikan, Vol. III, Plate 8.

12. Attributed to Su Han-ch'ēn. Children Playing. Ming (?).
 Ku-kung Collection.
 Reproduced from Ku Kung Shu Hua Chi, Vol. 39, Plate 3.

13. T'ang Yin, Gathering Medicinal Herbs. Early 16th c.
 Formerly Yamamoto Collection.
 Reproduced from Minshi Taika Gafu, Plate 36.

14. Ch'iu Ying, Evening at the T'ao-li-yüan. Middle 16th c.
 Chion-in, Kyoto.
 Reproduced from Tōsō Gemmin Meiga Taikan, Vol. IV, Plate 19.

15. Attributed to Wang Wei, Clearing after Snowfall. Sung (?).
 Hand-scroll. Ogawa Collection, Kyoto.

16. Fan K'uan, Travellers among Mountains and Streams. Early 11th c.
 Ku-kung Collection.

17. Anonymous, The Solitary House by the River. Early 12th c. (?).
 Ku-kung Collection.

18. Li T'ang, Landscape. Early 12th c.
 Koto-in, Daitokuji, Kyoto.

19. Li Kung-nien, Landscape. Late 12th c.
 The Art Museum, Princeton University.

20. Anonymous, Waterfall. Late 12th c.
 Chishaku-in, Kyoto.

21. Ying Yü-chien, Village in Clearing Mist. Early 13th c.
 Yoshikawa Collection, Tokyo.

22. Hsia Kuei, Rainy Landscape. Early 13th c.
 Album leaf. Museum of Fine Arts, Boston.

23. Ts'ao Chih-po, Study of Trees and Rocks. Early 14th c.
 Album leaf. The Art Museum, Princeton University.

24. Wang Mêng, Pine Forest and Stream in the Mountains. Dated 1367.
 Collection unknown.

25. Ni Tsan, Landscape. Dated 1372.
 Ku-kung Collection.

26. Shēn Chou, Hermitage by Mountain Stream. Dated 1464.
 Abe Collection, Municipal Museum, Osaka.

27. Chang Fêng, Viewing Maple Leaves. Middle 17th c.
 Yamato-bunka-kan, Nara.

28. Mei Ch'ing, View of Lien Hua. Late 17th c.
 Collection unknown.

29. Tao-chi, Waterfall on Lu-shan. Late 17th c.
 Sumitomo Collection, Kanagawa.

30. Tao-chi, Landscape in the Style of Ni Tsan. Dated 1697.
 The Art Museum, Princeton University.

31. Kao Chi-pei, Landscape. Early 18th c.
 Finger painting album leaf. Museum of East-Asiatic Art, Amsterdam.

32. Kung Hsien, House on Mountain Peak. Late 17th c.
 Collection unknown.

33. Anonymous, The Green Dragon of the East. Late 6th c.
 Fresco. Sammyoli, Korea.

34. Attributed to Chao K'o-hsiung, Fish at Play. Sung (?).
 Metropolitan Museum of Art, New York City.

35. Li Ti, Boy on Water-buffalo. Middle 12th c.
 Formerly Masuda Collection, Tokyo.

36. Yü Ch'ing-yen, Lotus in the Wind. Early 13th c.
 Chion-in, Kyoto.

37. Hsia Kuei, Reeds and Cranes. Early 13th c.
 Album leaf. Tomijiro Nakamura Collection, Kyoto.

38. Mu-ch'i, Monkey. Early 13th c.
 Daitokuji, Kyoto.

39. Attributed to Mu-ch'i, Persimmons. Early 13th c.
 Ryōko-in, Daitokuji, Kyoto.

40. Attributed to Mu-ch'i, Kingfisher. Late 13th c.
 Hakone Museum.

41. Attributed to Ch'ien Hsüan, Bird on a Branch.
 The Art Museum, Princeton University.

42. Chēng Ssū-hsiao, Two Epidendron Plants. Dated A.D. 1306.
 Abe Collection, Municipal Museum, Osaka.

43. Attributed to Wu Chēn, Bamboos in the Wind. Ming (?).
 Museum of Fine Arts, Boston.

44. Attributed to Ma Fēn, The Hundred Wild Geese. Ming (?).
 Honolulu Academy of Art.

45. Lin Liang, Phoenix. Early 16th c.
 Shōkokuji.

46. Chu Ta, Grasshoppers on Lotus Leaves. Middle 17th c.
 Album leaf. Author's Collection, Princeton.

47. Chih Pai-shih, Shrimps. Early 20th c.
 Author's Collection, Princeton.

PRINCIPLES OF CHINESE PAINTING

SUBJECT MATTER
AND ITS INTERPRETATION

INTRODUCTION

Art, like religion, deals with inner reality. The artist reveals the inside of life and not the outside. In this respect the artist is akin to the mystic, but one seeks "life more abundant" and the other becomes a creator. This creation is the product of the imaginative "wedding of spirit and matter," as the mediaeval schoolmen would phrase it. Every creation will differ according to the eyes through which the artist sees himself as creator, the raw material of experience which he transforms and the kind of ultimate spirit which he hopes to reflect. Is his Absolute a divine person or a blind force? Granted imagination, what other human faculty does he prize most highly, his faith, intuition, reason or senses? Can the natural world be analyzed or must it remain mysterious? Until the fundamentals are known about Nature, Man, and God, or as the Chinese put it, Heaven, Earth and Man, we cannot fully apprehend the art of any culture.

—What makes a painting Chinese? We never put it in words because the art itself is such a direct and immediate revelation of the spirit of the people. That spirit is so manifest that we seldom stop to ask why this pottery is Greek or that sculpture is Hindu, or why this figure must be Italian or that landscape English. Although these characteristics of the spirit seem self-evident, their roots lie deeply buried in the early orientations of the different cultures. They are the intangibles which embody the hopes and longings of a people; they are the incommensurables which determine the answers to the three basic issues of experience, Nature, Man, and God. Each culture seems to have had a special bent. Reason and corporeal beauty were the fortes of Greek art. The Hindus had such an urge toward religion that the religious symbol vies with the natural sensuousness of their tropical forms. Everywhere in the art of western Europe the importance of the individual person and his ingenuity in handling material and technical problems were paramount. In each case dominant cultural traits determined the character of the art. What was dominant in China? Here we meet a unique and surprising answer. The Chinese way of looking at life was not primarily through religion, or philosophy, or science, but through art. All their other activities seem to have been colored by their artistic sensitivity. Instead of religion, the Chinese preferred the art of living in the world; instead of rationalization, they indulged in poetic and imaginative thinking; and instead of science, they pursued the fantasies of astrology, alchemy, geomancy and fortune-telling. If these observations seem to be unduly imaginative, consider the painting in its own right. Chinese painting never became the handmaid of religion except during the influence of Buddhism, a foreign religion; it avoided the pitfalls of reason, whether the Greek beauty of mathematical proportions or the modern limitations of pure abstraction; it escaped the

[3]

glorification of the personal ego as exemplified by expressionism, romanticism, or surrealism; and lastly, it never emphasized imitation at the expense of the imaginative re-creation of experience. Unfortunately, it is very easy to say what Chinese painting is not, yet extremely difficult to say what it is.

The thesis of this work is that Chinese painting has been supreme in artistic purity. Not only have other disciplines failed to contaminate artistic creation, but the two chief modes of thought in China have been peculiarly favorable to art. Just as Christianity and the Hellenic tradition moulded our European art, in China the two indigenous doctrines of living, Taoism and Confucianism, determined the cultural climate in which Chinese painting would flourish. Obviously each of these orientations was reworked to suit the needs of successive historic periods. The Taoist spirit behind a Sung landscape was a far cry from the Taoist fancies of a Han bas-relief, and the Confucianism of Confucius was vastly expanded into Neo-Confucianism. However, for our purposes, since each doctrine embodied a certain constant outlook on life, the two modes of thought intermingled to establish the eventual content, form and overtones of Chinese painting. What did these two doctrines have in common which determined how the Chinese painters would attack the "wedding of spirit and matter"? *They both sought "inner reality" in a fusion of opposites.* That is, wherever the western mind would set up antagonistic dualisms—matter-spirit, divine-human, ideal-natural, classic-romantic, traditional-progressive, and so forth—the Chinese took a mediate position. Stated negatively, they tended to avoid extremes, in contrast to the western quest for reality by pursuing each extreme to its end. This has led the west to accuse the Chinese of compromise, of following a Confucian "mean," and of relativity in their approach to experience. This is not the place to argue the pros and cons of the Chinese position, except to point out that instead of being a static mean in which the extremes suffered, the Chinese fusion was a dynamic union of opposites which needed one another for completeness. The artist must be neither classic nor romantic, he should be both; his painting must be neither naturalistic nor idealistic, it must be both; his style must be neither traditional nor original, it must be both. Irrespective of the strengths or weaknesses of this Chinese approach, it was the way they sought the "inner reality" of their painting. The truth about the Chinese and their art resides somewhere between the western extremes, and therefore we will seek it by discussing a number of polarities which the Chinese have blended. This will have two merits: it will avoid the use of western terms, such as impressionistic or romantic, which completely falsify Chinese orientations; and, secondly, it will provide the fluid and relative field of nuance and overtone which is needed for the understanding of Chinese painting.

SPIRIT AND MATTER

WE will begin with the basic contrast of spirit and matter. In the west the gulf between them has been impassable. For us spirit belongs to the life of prayer and worship, matter is the concern of science. This has directed our art to the extremes of religious meaning and naturalistic representation. The Chinese, by not carrying empirical method far enough, failed to develop the natural sciences; and, by not pursuing the nature of spirit to the ultimate of a personal God, they never evolved a real religion in our sense of that word. Instead, the Chinese created a unique conception of the realm of the spirit which was one with the realm of matter. This meant that their painting would never become as religious, imitative, or personally expressive as our painting; and it also meant that art would tend to take over the functions of religion and philosophy and would become the prime vehicle for man's most profound thoughts and his feelings about the mystery of the universe. This unique conception of spirit and matter was embodied in the notion of the Tao.

The Tao, as primal source, was stated in Chapter xxv of the Tao Têh Ching: "There was something formless yet complete that existed before heaven and earth, without sound, without substance, dependent on nothing, unchanging, all-pervading, unfailing. One may think of it as the mother of all things under heaven. Its true name we do not know. Tao is the by-name that we give it." By the single daring assumption of the cosmic principle of the Tao, the Chinese focussed on the notion of one power permeating the whole universe, instead of emphasizing the western dualisms of spirit and matter, creator and created, animate and inaminate, and human and nonhuman. This concept of the Tao was the touchstone of Chinese painting which affected the creative imagination, the subject matter and the interpretations. Although it originated in musings about the cosmos, it became reworked by the Sung painters into the "living reality" which they sought to paint. In the catalogue of Hui Tsung we read that "when one approaches the wonderful, one knows not whether art is Tao or Tao is art." In the words of the Ch'ing painter, Wang Yü, "although painting is only one of the fine arts, it contains the Tao," and in discussing the birth of pictorial conception, the Sung connoisseur, Tung Yü, wrote:

> "Furthermore looking at the things made by heaven and earth
> One may find that one spirit causes all transformations.
> This moving power influences in a mysterious way
> All objects and gives them their fitness.
> No one knows what it is, yet it is something natural."

According to these quotations the activity of the artist approached that of the mystic in so far as Taoism may be called a kind of natural mysticism. Only instead of seeking union with God or the Absolute while ignoring this world, the Chinese artist sought harmony with the universe by communion with all things. In the choice of subject matter, themes from nature acquired new meaning because everything partook of the mystery of the Tao. To us a rock is an inert, inanimate object; to the Chinese a rock must be a living thing.

[5]

This idea of spirit in the inanimate is a difficult hurdle for the western mind. The Chinese recognize that man is different from the natural world and the lesser forms of being, since he is the self which experiences them, and since inanimate things lack consciousness; nevertheless, they would say that other forms of existence have a nature of their own, which is the Tao within them. The painter sees the soul of the mountain in its silhouette, with which he desires to identify himself. In the lines of Wang Wei:

> "These beautiful days in Hsiang-yang,
> Make drunken my old mountain heart."

No line of separation was drawn between the life of nature and the experience of man. They both belonged to the elemental being of the universe. In other words, the material world, unexplained by science, retained and assumed attributes which we would associate with the realm of the spirit. It is illuminating to note that some of the Sung painters made the distinction between inanimate natural objects and man-made artifacts, perhaps, because man had disturbed the operation of the Tao in them or because they could be rendered by a foot-rule. Certainly, these particular masters would never have appreciated cubism or machine-made art, and it may be that this is why our kind of still-life was practically omitted in the Chinese classifications of painting. Flowers must be growing or seem to be growing; fruits and vegetables, while inert, must possess an inner living quality so superbly realized in the famous "Six Persimmons" by Mu Ch'i. How dead so much of our still-life seems; how lifeless so many of our cut flowers appear in comparison with the life of the spirit suggested in Chinese fruits and plants. Before a single stalk of ink bamboo, or a few iris leaves, we see the world of nature through new eyes.

It was inevitable that landscape should become the supreme theme of painting. Landscape, as in other cultures, began as a setting for figures and in T'ang times was established in its own right, under the fathers of landscape painting, Li Ssŭ-hsün and Wang Wei. From the evidence of authentic works, this T'ang landscape remained essentially poetic in its character, a kind of glorified "garden" conception of nature in which the trees resembled flowering shrubs and the mountains seemed like a fanciful ensemble of miniature hills. This natural world, however, existed for itself and not as a vehicle for the moods of man; it was completely anonymous. As Li T'ai-po wrote, "it is another sky and earth, not the world of man." In Sung times, just when the painters were speculating about the relation between Tao and art, landscape painting began to imply a more comprehensive grasp of an all-embracing, limitless nature. The landscapists from Ching Hao to Kuo Hsi seemed to aim at a recreation of the natural world as a universal system comparable to the cosmic system. By sheer multiplicity of parts, piling mountain upon mountain, the painters created an overwhelming sense of the majesty and vastness of nature. By moving focus, from part to part, by avoiding compositional axes, and by opening up the views at the sides according to the advice of Kuo Hsi, the designs suggested a sequential experience in time and a movement beyond the limits of the painting into the boundless infinity of the universe. The same goal was realized during the Southern Sung dynasty by opposite means. In contrast to the multiple mountains of the earlier landscapes,

[6]

the scope was reduced to a few elements, such as a scholar drifting in a boat or meditating on a waterfall with a solitary mountain in the background. One would suppose that this more limited glimpse of nature should have suggested a specific place—a known quantity, capable of being objectively understood; instead, the Southern Sung artists perfected a new pictorial language of "brush pointing" and monochrome washes by which the known forms faded off into the void of the unknown. Whereas the unfathomable spirit of nature was implied in Northern Sung landscapes by the multiplicity of forms, now the mystery of that spirit was subtly suggested by the obliteration of form. In either case, space was not a measurable quantity but a vehicle for suggesting the immeasurable vastness, so that landscape became a visible symbol of an all-embracing universe.

This did not mean that the artist set out deliberately to paint the Tao, although some of the comments seem to evince this; rather, the notion of the Tao created the kind of speculation which was most fruitful for artistic creation. Artists think like artists and not like philosophers even in China where the painters were so often speculative thinkers as well as artists. Art tends to behave according to its own innate laws and predilections irrespective of analogies from philosophy or religion. Certainly most western writers have been guilty of confusing artistic with philosophical theorizing and have indiscriminately dragged the Tao into the picture without regard for its historical significance. For example, to associate Lao Tzǔ with Wordsworth and to say that "their conception of life and their philosophy of nature are the same" completely disregards the first principle of historical development as thoroughly as to have equated Pythagoras with Wordsworth. On the other hand, knowledge of the Tao was continuously present to influence the imagination of the painters even before it became so definitely identified with art in the Sung period. Therefore, it will be permissible to inquire what other notions, associated with the Tao, might have had bearing on artistic creation, in addition to the "oneness of spirit and matter" which implied for art that the Tao is in all things and that the Tao is limitless.

The Tao also manifests itself as an eternal flux of being and becoming. When the seasons 20 come and go, all things die and are reborn. It was said of the Tao:

> "Being great, it passes on;
> Passing on, it becomes remote;
> Having become remote, it returns."

How powerfully the dragon paintings have captured this quality of eternal energy. The Tao never sleeps. Forms appear and disappear in water, cloud or mist; their rhythms turn and twist in ceaseless becoming. According to Lawrence Binyon, "If Shelley had been a Chinese poet, his 'Ode to the West Wind' would have been addressed to the Dragon." Although some of our modern painters have tried to express the kind of energy which modern science has discovered, they have not had the benefit of such universally understood symbols. Confucius used another beautiful metaphor while standing beside a stream: "Ah! that which is passing is just like this, never ceasing day or night."

In flux there is movement. How will the Tao reveal its presence without movement? "Tao

does nothing but there is nothing that is not done." In many ways this was the most subtle and fruitful aspect of the Tao for inspiring an inner pictorial dynamism. The living quality in the Chinese rendering of static objects has already been noted, a quality which depended primarily on the rhythmic abstraction of the form. The idea of activity in tranquillity was further applied to all relationships. It generally resulted from a resolution of opposites, the yin and the yang. Only by opposites can we know something because:

> "Difficult and easy complete one another,
> Long and short test one another,
> High and low determine one another."

The yin-yang relation was supposed to set up tensions throughout the universe, between the great and the small, heaven and earth, male and female, and so on. The Tao resides in tension.
25 Landscape itself is a mountain-water picture in which the opposites need one another for completion. How often western landscapes have been exclusively studies of sky, sea, woods, meadows or some other dominant feature. Everywhere the Chinese have applied this principle of the resolution of opposites to their painting, in the laws of growth, in the layout of a composition, in the creative process itself, and even in the estimate of artistic values.

The significance of the nonexistent is the most obvious attribute of the Tao and yet the most elusive:

> "In Tao the only motion is returning,
> The only useful quality, weakness;
> For, though all creatures under heaven are products of Being,
> Being itself is the product of Not-being."

The use of the nonexistent in painting, that is voids, began historically with the neutral backgrounds which were characteristic of all early art, and the Pre-T'ang pictorial designs were no exception. In western painting these neutral voids were supplanted by the discovery of space and its rendering as blue sky, clouds and atmosphere. The Chinese transformed the neutral voids of early painting into the spirit voids of the Sung period. Finally, in the thirteenth
21 century the painters had become so aware of the significance of the nonexistent that the voids said more than the solids. By Ch'ing times these voids had degenerated into meaningless blank paper because the painters had lost their touch with the profundities of the Tao and had begun to indulge in "art for art's sake." Again we note that the use of the nonexistent in painting was far removed in time from the symbols of the usefulness of voids employed by the early Taoists—such as the vacuum in a wheel, a vessel or a house, and yet the kind of speculation enjoyed by Lao Tzŭ and Chuang Tzŭ produced a cultural climate in which such notations might eventually flower into the emptiness, limitlessness and intangibility achieved in the paintings. In fact, the Tao, with its associated notions of the oneness of "spirit and matter," the eternal flux of all things, the resolution of opposites, and the significance of the nonexistent, was the cornerstone on which the Chinese based their painting and their theories of painting.

[8]

MYSTICISM is the direct experience of "ultimate reality." Strictly speaking, no art is mystical. The phrase natural mysticism has been used to contrast the Tao and its influence on art with the other kinds of mysticism, whether Hindu, Neo-Platonic or Christian and the arts associated with them. The distinction hinges on other-worldliness and this-worldliness, or heaven and earth. If an artist gazes too hard towards either, the lack of balance will show in his art. If an age concentrates on the other world, this world must necessarily seem lacking in significance, so that the artists, while avoiding the physical, will try to depict an other-worldly realm of bliss. Such an attempt is best illustrated by Byzantine art, in which the goal of the artist was to create holy icons to be worshipped at the altars, or to decorate the walls of the churches with mosaics to inspire awe and wonder. The effulgence of the heavenly realm was suggested by gold backgrounds and the glitter of gems of the Byzantine court which symbolized the heavenly rule on earth. The bodily forms were so denaturalized into schematic shapes that they all seem to approach the archangel types as their ideal. Okakura once linked this Byzantine art with his own Far Eastern art when he commented that we claimed that art in Europe began with Cimabue, while he insisted that it ended with that master. Obviously he was objecting to the Renaissance interest in representational fidelity in contrast to the Chinese and Byzantine attempts to transcend the physical, although he was completely misleading in linking these last two together. The Chinese approach avoided every pictorial invention which might direct the imagination toward other-worldliness, just the reverse of the Byzantine. The Tao of heaven belonged equally to earth. However, the very fact that it made itself manifest on earth seemed to have restrained the Chinese from painting the ugly, the sordid, or the deformed. One will look in vain for parallels to scenes and episodes which can be found in Bosch or Grünewald or those romantics who painted the terrors of the natural world. There are no deserts, gruesome swamps, or desolate places in Chinese painting. Nor were hybrid creatures, deformed plants or tortured trees considered fitting vehicles for imparting the Tao on earth. Most revealing of all is the absence of the usual or the commonplace. The Chinese have avoided both extremes either of this-worldliness or of other-worldliness, and, while painting natural scenes, they have been able to lead our thoughts toward the mystery beyond the natural.

That true other-worldliness was alien to Chinese orientations toward life was further demonstrated by the degeneration of Taoism into Occult Taoism. This debased form took over the popular folklore of China and expressed itself in legendary themes of the "Queen Mother of the West," the divinities of the air, sea and stars, the bird-men sprites and other hybrid 3 creatures, the immortals or hsien, together with all the crude imaginings so characteristic of art when it falls into the hands of the illiterate. This was a fairy conception of the supernatural; the immortality of the Taoist hsien consisted of a prolongation of physical old age in which the immortal was freed from the ills of life and was granted the magical powers of subsisting on dew and of riding through the air to the eastern "Isles of the Blest," or to the mountain paradise of the "Queen Mother" in the west. When magic is the approach to the supernatural,

it will always bring the imagination back to earth again. The immortals and the fairy realms were still earthbound in contrast to the more other-worldly Christian conceptions of the celestial realm where man ascends in Dantesque fashion ever higher away from the earthly plane toward the heavenly light. The contrast between the Christian and the Chinese may be forcefully illustrated by putting the western clouds and unearthly light of paradise beside the wild cavortings of the Taoist hsien in a "mountain-water" setting. The Occult Taoist paintings were the figure counterparts of the dragon scrolls. They symbolized the forces of nature and they were rendered in free rhythmic movements which we usually associate with such elements as speeding clouds, windblown foliage, and running waters. On the other hand, they expressed an immature conception of the supernatural in terms of fairy realms.

DIVINE AND HUMAN

THE non-religious character of Chinese painting makes us realize the debt of the west to Christianity. The gulf between God and man gave birth to intense emotions which are conspicuous by their absence in China. Everywhere we meet the Christian extremes of good and evil, of sin and repentance, and of divine love and human need. Rembrandt immortalized grief and suffering and forgiveness. The *terribilità* of Michelangelo caught the dramatic struggle of man's free will. To minds attuned to these religious overtones Chinese painting seems to reveal another kind of human world.

Neither Taoism nor Confucianism offered a religious answer to the question of "What is man that Thou art mindful of him?" The Tao was impersonal, and therefore the personal relation, or its antithesis, between the divine and the human did not arise. As we have already seen, it was a unique type of mysticism by virtue of which expression through art was more germane than through religion. Confucianism, also, was not a true religion and therefore could not give a religious answer to man's search for higher life. The role of Confucianism in the conduct of Chinese society is one of the amazing phenomena of human history. How was 4 it possible that a humanistic doctrine should have survived for two thousand years without the deification of Confucius and the sanction of religious belief? Perhaps it was because ancestor worship really satisfied the religious needs of the Chinese, or because Buddhism was adopted 6 at an opportune moment, or possibly because Taoism offered a sense of the mystery of the universe.

A more positive reason lies in the nature of Confucian humanism. Indeed, humanism is just as much a misnomer for Confucianism as mysticism was for Taoism. It is true that Confucianism centered on man's relation to man, that it had little interest in metaphysics, and that it avoided the unknown while accepting its existence. "Until a man knows about living, how can he know about the dead?" However, it was much more than a humanism in which man depended only upon himself. Straight humanism has a tendency to go mundane and to omit the best in human experience. The humanism of Confucius possessed a power which approached that of religion by its recognition of sanctions greater than human, since ancestor worship gave man a sense of permanence and a special dignity. Confucius also saw man in the perspective of a moral universe in which the moral order of earth was synchronized with the order of 1 heaven through the "Son of Heaven" as a regulator. Just as the heavenly bodies rotated around the Pole Star, so must the earthly organizations revolve around the ruler, and in this way the five relationships were tied up with the cosmic system. "He who understood the Great Sacrifices could grasp the cosmic system as clearly as if in the palm of his hand." Ritual and learning 7 were the roads to the goal of social harmony and they derived their authority not from contemporary human wisdom but from the ancients or from legendary ancestors through custom and the classics. Therefore the highest type of man was the Confucian gentleman-scholar 10 who held "jên," or the good relation between man and man, to be the highest virtue, supported by the additional virtues of rightness, decorum, wisdom and sincerity. This conception of a

moral universe and its ethical virtues lent a moral tone rather than a religious emphasis to Chinese painting.

According to Confucianism, greatness in painting requires high moral character in the artist. Chang Yên-yüan wrote: "From ancient times, those who left excellent paintings were all high officials, noblemen, great scholars, or men of high moral character." Another writer insisted that the important thing in painting was the "gentlemanly spirit," and another "that the heart and character of the man should be developed, then he can express high principles and a pure vitality." Likewise, the themes suitable for painting must be worthy. Although later artists did not adhere strictly to Hsieh Ho's statement that "there is no picture which is not intended for some moral purpose," figure subjects continued on a lofty plane while they differed in characterization according to the taste of the various periods. The subtle change in moral tone may be seen in the contrast between Ku K'ai-chih's "Admonition to the Ladies of the Palace" and Ch'iu Ying's "Women and Children at Play." In one the moral precept was driven home by a didactic story, and in the other the human relationship was ennobled as a family pastime. The dignity and decorum of human society must have been supremely realized in Li Kung-lin's famous painting of the "Western Garden," in which he and his friends were shown practicing the arts. To western minds, accustomed to the portrayal of Greek gods and the Christian hierarchy, or acquainted with the exploits of classical heroes and the scenes from the life of Christ, Confucian themes may seem quite everyday in character, but nevertheless they are so imbued with deeper meaning that they are never genre in spirit. If we really enter into the Chinese mind, we well realize that these themes inculcated moral principles and that they embodied the whole organization of life, including the worship of ancestors, the five relations, and the conception of the family as the basic unit of society; they also taught the lessons of history and glorified the scholarly life as the ideal pursuit of man. Consequently, these overtones of profound significance raised the apparently secular subject matter to a plane corresponding to the religious content of western painting. Through ritual and the proprieties, Confucianism inspired the decorum of life and the graciousness of harmonious living. Reverence and ritualistic decorum were the Confucian guides and they are qualities which we would seldom ascribe to western painting unless it had a religious content. Europe has tended toward the humanization of religious themes while China has enriched secular subject matter with her loftiest aspirations. Between straight humanism and pure theism the Chinese have taken an intermediate position.

THUS far we have outlined the general orientations of the Chinese toward "Heaven, Earth and Man"; now we must study the artist himself and his artistic problems. When the Chinese listed the qualities to be desired in an artist, they invariably combined Taoist and Confucian opposites. Just as the two doctrines were blended in Neo-Confucianism, they were united in the artist himself, who was usually both a Confucian scholar in his training and a Taoist recluse in his longings. This fusion of opposing virtues has given the Chinese painter balance and strength. Greatness was assured when the stability of Confucian conformity, moderation and lucidity was added to the imagination of Taoist freedom, naturalness and mystery. Shên Tsung-ch'ien listed four ways of developing a personality of high quality, namely:

> "To purify your heart in order to eliminate vulgar worries,
> To read books widely in order to understand the realm of the principles (li),
> To renounce early reputation in order to become far-reaching,
> To associate with cultivated people in order to rectify your style."

The first and third ways are Taoist and the second and fourth are Confucian. Another writer, in discussing cultivation or elegance, which was the supreme Confucian quality in both the painter and his painting, enumerated four Taoist virtues as the roads to elegance, namely: to be "cranky"—going against the world, "foolish"—forgetting about the world, "poor"—being contrary to the world, and "remote"—being far from the ways of the world and thus able to preserve elegance. This may seem contradictory, but if we attempt to systematize these yin-yang opposites we will discover that they reveal subtle insights into the nature of the artist and his training. The painter must possess humility and retreat from fame because the spirit comes only to the truly receptive; at the same time he must be profound and his art far-reaching in its universality. The painter must be pure in spirit, free from everything profane, and yet he must read widely and travel extensively. "How can one be the father of painting without reading ten thousand books and travelling ten thousand miles?" Poverty 7 should be his lot, since only he attains freedom who no longer craves possessions, power and pleasure; on the other hand, Li Kung-lin and many other painters were admired for their zeal as collectors. There was nothing either bourgeois or primitive about the Chinese painters since they belonged to an intellectual aristocracy and prized the rare products of civilization. 11 Above all else the painter depended on natural gifts and should preserve his naturalness but he must go to the wisdom of the ancients to perfect his natural endowment. "In exercising one's own individuality (hsing ssŭ), not for one moment can you forget the ancients." In execution, effortlessness was the highest goal and yet the rules must be known and never be forgotten. 27 Unless the artist was sincere he might fall to the level of the professional painters who simply try to "seduce the eyes of the common people in order to earn much gold"; however, he must not take himself too seriously. Painting should be the playful pastime of a scholar, even though one should prepare to paint, "as if to receive an important guest." Without diligence,

[13]

painting will lack completeness so that Kuo Hsi advised working as if "guarding against a strong enemy"; on the other hand the Chinese appreciated the law of reversed effort according to which the attention must not be too firmly fixed on the effort lest the psychological pull of the desired end should be lessened. Simplicity was often linked with spontaneity in importance. A Ming painter said: "Simplicity means not to be ostentatious; it is the same thing as that which is called the refinement of a really cultured man." At the same time the painter should achieve maturity, he should be many-sided and he should practice many different styles in forming his own style. Once he has attained an individual style, he must be able to say much with little. Lastly, the true painter has much of the fool in him. Ku K'ai-chih excelled in buffoonery and Huang Kung-wang called himself the "Great Taoist Fool." Painters were expected to be foolish, crazy, cranky or eccentric; however, they must also achieve yün or correctness of style.

Yün has been translated harmony, resonance and correctness. In Hsieh Ho's first canon it was linked with ch'i, or spirit, in the famous phrase ch'i yün, or spirit resonance. Here it obviously meant the way in which spirit manifests itself—that is, style in the broadest sense. When the Sung painter Ching Hao made yün his second principle, he analyzed its dual aspect thus: "Yün conceals trace, sets up form," referring to the pictorial manifestation of the ch'i spirit; and secondly, "presents aspect, not vulgar," describing a critical ideal of style, the opposite of the low, mean and commonplace. In the Ming enumeration of the five beauties and five evils of painting, Li Shih-ta used yün in the sense of correctness as opposed to foolishness. In each of these instances we encounter an ideal of style bred in Confucian respect for tradition, propriety, and culture. Yün concerned following the rules and knowing the laws of nature, both of which acted as brakes against too much originality and eccentricity. "A painter should develop his own individuality but he should follow the rules." The Chinese have insisted that freedom and sound tradition are not incompatible and that their painters should possess both the Taoist and the Confucian virtues. Confucianism emphasized the virtues which concerned moral character and intellectual cultivation, while Taoism dealt with the creative traits of meditation and spontaneity.

PERSONAL AND IMPERSONAL

IN view of what has been said about Taoism and Confucianism, we would not expect Chinese painting to be assertive in personal traits. Personality depends upon distinctions and not upon sameness. In the west, the individual person, as a child of God, was given a special value by Christianity, and that value later degenerated and became distorted into the romantically magnified ego of modern man. In China, although individuality was appreciated, the extreme development of personal idiosyncrasies was checked by the necessity of conforming to the social order of Confucianism or to the natural harmony of Taoism. In spite of the freedom and spontaneity of Taoism, the goal of man was harmony with nature rather than the development of personal significance. Likewise, to the Confucianist, the meaning of life was to be found in moral goodness which rested on the social order of the rites and not on the sanctions of the individual soul. Confucius said, "Music initiates the harmony of the universe, rites 8 initiate the order of the universe." In either case harmony was man's goal. This meant that the passive states of decorum and tranquillity were prized more than the active emotions of love and struggle. Psychologically, in the west achievement of unattainable ends has been man's quest, either "to do the will of God" or to struggle toward the ever-advancing goal of progress; in contrast, the Chinese valued the restraint and suppression of desires, which would lead to the passive states of decorum and tranquillity. This difference in ultimate goals conditioned all the personal and emotional overtones of Chinese painting.

The attitude of a people toward personality is best revealed in their portraiture. To create 7 a living personality has been one of the great achievements of western painting while there has been no Chinese Titian, Raphael or Rembrandt. On the other hand, the scholar-painters of China looked down upon the mere description of physiognomy and considered the painting of ancestral portraits by professional craftsmen as an inferior art. To our eyes, these ancestral portraits have had a special appeal, probably because of their decorative value or superficial similarity to artists like Holbein. Many of them achieve nothing more than careful descriptions of characteristic features; many of them were artificially assembled from stock types of nose, eyes, mouth and chin. However, some of them retained something of the indefinable inner spirit which was the aim of the scholar-painters. They desired to catch the spirit, or shên, rather 2 than the form and features; according to a seventeenth-century critic, "to see the spirit of a man is like watching a bird cross your vision, the faster he flies the greater the spirit, and therefore the briefest glimpse of a person is when you catch the spirit most." Obviously this fleeting glimpse could not reveal a complete personality but the essential "being" of the man. We, in the west, seldom reduce spirit to a single characteristic, as the Chinese do when they speak of the craziness of Mi Fei, the loftiness of Ni Tsan, or the purity of Wu Chên. "Just as 25 heaven gives the spirit (ch'i) appropriate to each season, the portraitist should seek the right spirit (shên) of man." This Chinese method has affinities with caricature without its animus.

Historically, however, the Chinese approach to portraiture went back to early times. "The ancients used only a few outline strokes yet they captured the different kinds of spirit, such as

[15]

5 the heroic and the elegant." Ku K'ai-chih added three hairs to the chin of a portrait in order to bring out a sense of dignity. "Sometimes the spirit of the sitter is centered in one place or feature, at the 'orchid terrace' (either side of the nose), at the mouth or eyes, and sometimes this characteristic aspect belongs to a more general quality, such as skin texture or complexion." During the Yüan period, the painters became so much more interested in physical appearance that they studied the so-called science of physiognomy and applied additional modelling to the face; at the same time, the drapery was often rendered in the sketchy brush tradition of the Southern Sung painters. The Ch'ing scholars claimed that the proper methods were lost with Ch'iu Ying and that artists like Huang Shên corrupted the eyes of the public with their crooked and curving lines, their improper short stops, and their violent hopping and jumping. In the pure brush tradition of Sung times the Chinese have shown how the essentials of living human spirit might be captured. The supreme example was the famous

10 portrait of Li Po by Liang K'ai, in which the figure seems to walk on air and the tilt of the head suggests an indescribable vitality of spirit. Although this was not a contemporary portrait but an imaginary portrait of a poet, who had lived five centuries earlier, how utterly different it is from our western types of Homer or other Greek worthies. They seem like intellectualized and impersonal compounds of personal characteristics beside the Sung immediate and intuitive distillations of inner spirit. Therefore we may say that in portraiture the Chinese again took an intermediate position between two extremes—the complete living personality and the more impersonal ideal type.

In the expression of emotion the Chinese are even more unlike us than in the distillation of personality. The richness of western content has leaned so heavily on the portrayal of love, joy, grief, anger and courage that we are apt to think of Chinese painting as unemotional. In China, no matter how intensely one might feel, there was always the face of propriety to be shown to the world. To them, we seem so indecent in our abandonment to emotions that a Chinese philosopher likened the difference between west and east to that between wild and domesticated animals. The emotions were ever suspect because they tied men to their appetites and passions and kept them from attaining pure and noble spirits. The Greeks also distrusted the emotions and turned to reason for the higher life. It remained for Western Christianity to harness the emotions to spiritual ends and to achieve depth of expression in the suffering and ecstasy of the saints.

To some extent we fail to find emotional intensity in Chinese painting because of the omission of themes with which we associate our deepest feelings, mother love, romantic love and the boundless longings of youth, enraptured by beauty of body and intoxicated with life. In their place, the Chinese honored the five relationships, the devotion of friends and the wisdom of old age. The moods of Chinese figures are neither gay nor sad, neither frivolous nor stern; they observe a mean. They may not know happiness which is the reward of struggle but they are full of a most satisfying contentment. A Chinese who visited a museum of modern art found the paintings much too exciting and exclaimed, "It is the painting of war and what we need is the painting of peace to calm men's passions." Little did he realize that he was reacting to normal western content, which to his eyes seemed so emotionally stimulating that it must have been caused by the psychoses of war. He had been raised on attitudes such as Ching Hao expressed: "Lusts and desires are the enemies of life. Wise men devote themselves to music, calligraphy and painting, thus one by one getting rid of their desires." *11*

How, then, will the Chinese handle drama? Since the heart of the dramatic resides in the emotional clash between personalities, we would not expect great drama in Chinese painting. However, their substitutes for dramatic effects throw light on their approach both to personality and to emotion. In many ways the painters employed methods similar to those which developed in the Chinese theater, namely pantomime, choreographic postures, and ceremonial routines, omitting the histrionic gesticulations of the stage. The faces are most restrained in expression, even when the situation calls for grief, anger or some other violent emotion. The postures never become angular or assertive, so that everyday tasks, such as silk weaving, often assume the solemn movements of a ritual. The relationship between the figures depends more upon the design than upon gestures to carry an emotional current from one figure to another. The figures themselves prefer to remain passive and, whenever possible, seem to retire into their own reticence. Keep everything quiet; never shout but whisper your emotions.

When physical action was required, either in running, playing or fighting, the Chinese resorted to various methods for avoiding the violence of naturalistic portrayal. In children at

12 play, no matter how delightfully they gambol, they look like little men dancing or acting, instead of falling into the rough and tumble of a western painting. Everywhere, the decorum of rites and customs seems to regulate human behavior. Whether an emperor competes with his generals or ties his shoe, the proprieties have prescribed the correct postures and gestures *14* and even a drinking bout approximates a discussion among scholars. Only demons, immortals and demon-quellers are permitted to kick and scream and rush madly about. The most effective device for streamlining the brutality of violent action was to make the human figure *9* follow the rhythms of nature so that the emotions, which we would normally associate with leaping forms, with wide flung arms or with tortured postures, become merged with our reactions to heaving rocks and plunging waters and twisted trees. The Chinese not only suppressed violent emotions; they made a bridge between human emotions and the moods of nature. This raises puzzling questions as to the use of mood in painting.

Moods are sustained feelings, less intense than emotions. Emotion thrives on concrete, specific situations; mood arises from indefinite, less individual experience. In painting, emotions are the raw material of normal contacts between people; moods require some special treatment. To create the vague, elusive quality of a mood, western figure painters have leaned heavily on poetical, allegorical and romantic associations. By contrast the Chinese preferred overtones *27* from nature and the scattered allusions to nature in Chinese writings are so profuse that they cannot even be summarized. Occasional lists were made, such as the fifteen observations of the "Mustard Seed Garden," which linked books with drifting in a boat, the musical ch'in with wandering in spring, or tramping through snow with searching for plum blossoms. Many plants had associations with types of men and with definite moods: the plum, lean and pure, should be paired with poets; the bamboo, sparse and cultivated, should be paired with scholars. According to Chang Ch'ao in the seventeenth century:

> "The plum flower makes a man feel high-minded
> The stork gives a man the romantic manner,
> The horse gives a man the heroic manner,
> The orchid gives a man the recluse's manner,
> And the pine gives a man the grand manner of the ancients."*

Many of these overtones need special literary knowledge such as is the case with our own allegories. On the other hand, so many of them carry the universal appeal of natural associations that very often we will find ourselves more attuned to the mood of a Chinese painting if we contemplate it "with the heart of mountain and streams." For example, a lone fisherman by a snow-laden river may convey the coldness and solitude of the wintry day rather than any sense of human discomfiture.

In the painting of themes from nature, mood was the essential of the subject. Bamboo was *43* painted in every kind of mood, quiescent or windblown, in sunshine or in rain, with dew, frost or snow upon it, in the morning and in the evening, each effect so subtly rendered that it sometimes escapes us. In the classifications by Kuo Hsi and Han Cho, the mountains, waters,

* Lin Yutang, *The Importance of Living*, p. 328.

[18]

trees, clouds, mists and winds must obey the seasons. The mountains should be "tranquil and [26] captivating" in spring, "fresh and green" in summer, "clear and neat" in autumn, and "melancholy and subdued" in winter. It was undoubtedly the importance of mood which led Ching [15] Hao to make "seasonal aspect" the fourth of his "Six Essentials" and in the Ming period each month was allotted appropriate themes with their attendant moods. Even the titles of the paintings indicate this Chinese interest in mood: "Pure Serenity of Green Bamboo," "Clearing after Snow," or "Peach Blossom Spring."

Moods may also be aroused by the purely formal treatment of the themes. Although the specific content of a Persian painting may be unknown to us, the arabesques of color and pattern create moods akin to those of music and many modern painters depend on pure abstractions to establish an emotional tone. To what extent did the Chinese employ set modes of pictorial language to express codified moods? By Ming-Ch'ing times eighteen styles of drapery line and sixteen types of wrinkle, or tsun, for mountains had been classified and the rhythmic [28] brush character of each of these was held to be appropriate to certain moods. In figure painting they ranged from the uniform dignified "ch'in-string" line of official portraiture to the blunt "brushwood" strokes of beggars and hermits; the titles of many of the styles show the [6] intimate relation with natural rhythms, the "broken-reed," "willow-leaf," "bamboo-leaf," and "scudding-cloud" or "running-water" strokes. Although the Chinese did not apply these styles as rigidly as the Japanese, who copied them, their suitability for different moods was appreciated. In landscape painting the sixteen styles were directly inspired by the crystalline structures of the various kinds of rock, creating in us the same feelings as do the mountain contours from which they were derived. Wrinkles like the "veins of a lotus" imply steep mountain peaks deeply cut with furrows, while the "unravelled rope" strokes suggest granite structures. The "confused clouds" of Kuo Hsi look like wind erosion, while the "rain drops" of Fan K'uan describe heavy weathering. Since we have no exact parallel to these modes [16] in western painting, we might liken them to the architectural orders in which we associate solemn dignity with the Doric, and lighter elegance with the Ionic order. In both cases, the Greek orders and the Chinese modes of drapery and landscape have the power to suggest types of mood. Moreover, Chinese moods did not spring from some extraneous association but were derived directly from the artist's experience of nature and were expressed in the rhythmic language of painting.

This codification of styles and their association with definite artists or schools gave both permanence and universality to the moods and modes of Chinese painting. The use of standard themes with recognized seasonal aspects compensated for the vagueness and instability of moods. If our artists had painted selected views of the Thames, the Seine, the Arno or the Delaware Rivers at certain times of day or under special weather conditions, then we too would enjoy an enrichment of moods comparable to the pleasure of the Chinese in the "Eight Views of the Hsiao and Hsiang Rivers," or in Kuo Hsi's themes of the seasons: "evening glow on a spring mountain, clearing after rain on an autumn plain, or a mountain cottage after snow." Also, these moods of nature were still further enhanced for the Chinese by virtue of the doctrine of man's unique relation to nature.

19 THE relation between man and nature in China was characterized by harmony and communion. In the west we have inclined toward the two extremes of human domination or of human inadequacy; man has been considered the "lord of creation" or else a victim of the cruel forces of nature. In either case, man and nature were alien to one another, and when the European attempted to bridge the gap between them, he was perforce romantic. Chinese painting was not romantic. This distinction resides in the reality attributed to nature. We must never forget that a culture which is sustained by faith in a personal God cannot seek reality in nature, and that the Chinese, without that faith, could find a reality in nature beyond our understanding.

The importance and independence of nature in Chinese painting was attested in many ways. First and foremost, the Chinese preferred free and remote scenes; most Chinese landscape

29 paintings depict untrammeled nature—mountains, gorges, waterfalls, streams and lakes, in contrast to our domesticated landscape—farms, meadows, canals, windmills and lakeside dwellings. Many Dutch landscape paintings seem like portraits of man's possessions, while the French and English portrayed their attachment to their local countryside. When remote scenery was first made popular by the German and Flemish painters they fashioned it to look like cosmographic maps, filled with their newly acquired scientific interest in unusual phenomena such as glaciers, weird mountain shapes, cliff-dwellers and all manner of strange creatures. Although the actual scene was extensive, the conception of nature was still physical and global. On the other hand, even when the Chinese painted an intimate scene they still

27 suggested that man and nature should meet on equal terms.

In their choice of human habitations the Chinese usually tried to intimate man's experience of nature rather than his domination of it. A pavilion was a key to a view, a thatched cottage

24 indicated a scholar's mountain retreat; even temples and palaces appeared to be places for meditation on the wonder and mystery of nature. Equally illuminating is the Chinese painter's avoidance of engineering feats or anything which would suggest man's conquest of nature, or, on the other hand, of ruins or wrecks, which would show nature's control over man.

Human activities were also selected to direct our interest toward the landscape rather than toward the human figures. In view of their agricultural life we would have expected parallels to the western "Labors of the Months," or their progeny, the later tillers of the soil. On the contrary, these were rare except in book illustrations of rice and silk culture and except in special cases, such as the Chanist herdboy with his water buffalo, which symbolized man's

11 control over his own unruly nature. Instead, we encounter scholars playing games or music which in western painting would be confined to interiors or terrace settings, but which the Chinese place in the wide out-of-doors to suggest the harmonious relation between human and natural activities. Most of the Chinese activities directed the spectator to a new awareness of nature and its relationships. A climbing figure would be a clue to a mountain path and seated figures indicate a place for viewing the moon or waterfall; figures in boats were lost in medi-

16 tation rather than in the joys of fishing; pack trains and groups at ferry-landings suggested

routes to mountain fastnesses and river outings. Europeans emphasized man's enjoyment of nature, sometimes not above the picnic or excursion level; the Chinese revealed the possibility of a more profound relation between man and nature.

How, then, can a deeper relation be achieved? The Greek tradition offered the personifications of classical allegory to make the forces of nature more humanly intelligible to man, or indulged in the pastoral idealization of rural life. The Middle Ages pictured nature as the handiwork of God; the Renaissance and modern periods resorted to the emphatic attribution of human emotions to natural phenomena. In all of these efforts to make nature seem less alien to man, the emphasis was put upon man's experience of nature and not upon nature for itself. The special merit of the Chinese was their feeling that nature is to be understood on her own terms. When Chou Mu-shih slept in a boat so that "his dreams might mingle with those of the lotus," it seems to us suspiciously romantic or sentimental in the western sense, but the Chinese believed that the lotus had its own dreams and not human ones. Landscape, plants and non-human creatures all have lives of their own, which can be apprehended only by understanding the principles of those other realms. Landscape cannot misbehave itself: it obeys the laws of climate, geography and the seasons; laws of growth determine the structure and relationship of its parts. When a Chinese painter compared a great mountain encircled by *17* smaller mountains to the emperor surrounded by his court, or spoke of the host and guest trees, he was not personalizing nature but observing its principles. Although Chinese painters wrote more voluminously about pictorial principles, the laws of nature were their foundations. The Sung writers began their texts with observations of terrain. Han Cho observed that "southern mountains are low and small but with lots of water and the appearance of the rivers and lakes is fair and beautiful, while the northern mountains are vast with many low hills and the trees and woods are abundant but the waters are narrow." The same painter observed the way trees grow on various kinds of mountains and the effects of clouds, fog, mist and fair weather. In the seventeenth century, Ta Ch'ung-kuang devoted half of his couplets to more specific comments. "Slender bamboos show between mountain pools, tall pines hug closely to the lofty cliffs." "Where mountains meet, water pours forth." Even without these direct ob- *18* servations of natural laws, the many stories about the preparation of the artist before painting would prove their awareness of the necessity of thorough knowledge of nature in its own right. Fan K'uan spent months of wandering through the snow so that he could paint the "very *16* bones of the mountains." The oft-quoted story of how Wu Tao-tzǔ dashed off hundreds of miles of river landscape because he "had it all in his heart" referred not only to the incredible memory possessed by all Chinese painters, but also to the fact that Wu knew the principles of nature so thoroughly that he could re-create them. Such knowledge was the gateway of the Chinese artist to real communion with nature.

Although the Chinese sometimes indulged in personalizing nature in order to reach greater intimacy, the western approaches to nature were never able to maintain their popularity. The Han personification of the storm, sea and star divinities did not survive as did the Greek *3* allegories in the west. The poetical appreciation of T'ang times was soon supplanted by the

[21]

more philosophical Sung conception of nature. The sentimentalizing of bucolic life never found favor in China because it signified condescension on the part of man who played at "going back to nature." There was nothing faked about the Chinese painter's rusticity; often he led the equivalent of a peasant life and always he desired the simplicity of direct physical contact with nature just as he sought intellectual knowledge of natural principles. That was why the Chinese poet could truly say, "The mountain and I never grow tired of one another." To the Chinese, real communion could exist only between equals.

Was this communion romantic? It has been likened to the romanticism of Rousseau, Wordsworth and the romantic landscapists. Or was the Taoist approach to nature radically different from this kind of romanticism? It is not surprising that most western authorities have confused the two, since they both valued intuition and imagination above reason, they both made a cult of freedom, they both longed for solitude and meditation, and they both sought a mystery beyond the usual routine of life, whatever form that unknown might assume; yet Taoism and Romanticism were directly opposed in all their fundamentals—that is, in their conception of the self who had the experience of nature, in their emotional attitudes, and in their ultimate goals. We will realize the contrast between them if we place paintings in the style of Ma Yüan, Hsia Kuei or even Kun Ts'an beside paintings by Friedrich, Morgenstern, Wilson or Turner.

Philosophically, the locus of that kind of western romanticism was the emotional tension between actuality and longing. It began with the aggrandizement of the ego and its desires as expressed in the words of Rousseau, "I am a man like other men but I am also different"; it asserted itself in revolt against the conditions of actuality which might be commonplace, the restrictions of convention, or the artificiality of city life; its emotional overtones thrived on the strange, the unusual and the imagined; lastly, the romantic goal was some kind of escape toward the unattainable, whether into the heroic past which can never be reclaimed, or into a fanciful existence in foreign climes, or into a kind of pantheistic return to nature. If this is a correct summary, the four essentials of romanticism were an assertive ego, the active emotion of revolt, a longing for the unusual, and the psychology of escapism. On all four counts the Chinese Taoist held contrary views.

In the approach to nature the Chinese believed that the self should be passive. The painter should resolve the paradoxes of life and he should conquer his desires in order that his spirit might be contained and receptive to the Tao. In contrast, the romanticist was a bundle of longings and full of melancholy self-pity—a state which may be harmless in a clown but diabolical in a dictator. The Chinese painter was capable of real tranquillity while the romanticist was apt to be restless and dissatisfied. Delacroix said, "The result of my days is always the same, an infinite desire for what can never be obtained, a void it is impossible to fill." The romanticist was deadly serious while the Taoist could smile or laugh colossally. Both were introspective, but one might shut himself up in morbid inwardness while the other sought a solitude which was not lonely. In the eighth century, the poet-painter Wang Wei wrote of a "Retreat among Bamboos":

"Leaning alone in the close bamboos,
I am playing my lute and humming a song
Too softly for anyone to hear
Except my comrade, the bright moon."

This scene was depicted ten centuries later by Wang Hui in a copy of Wang Wei.

The romanticizing imagination was not satisfied with nature itself. Novales summed it up when he wrote: "In giving the usual a noble sense; the ordinary, a mysterious appearance; the well known, the dignity of the unknown; the temporal, a perennial aura, I am romanticizing." Romanticism was a personalizing alchemy which turned things into what you wanted them to be; Taoism sought the truth of things as they are in reality. This distinction we have missed because we have stressed the desire of both to escape to the natural world. Assuredly the Chinese complained about the restraints of officialdom, and every Chinese painter would have agreed that "the world is too much with us." However, the crux of the matter is escape to what? Is nature reality or unreality? The very word romantic suggests the fictitious world of romance. Again we come back to the refusal of the western mind to find reality in a material realm. In order to invest the natural world with adequate awe, sublimity and mystery, the romantic painters resorted to wild, mountain scenery similar to the terrain of Chinese landscape painting; but in so doing they encountered strangeness, violence and danger, which were terrorizing. At his first sight of such landscape, Palgrave described it as "savage, rude and tremendous." Before such nature, if regarded in physical terms, man must cower in fright, but to the Taoist the most awesome mountains seemed like his spiritual home because both *29* nature and human nature partook of the same Tao. Chinese scholars sit cozily at the edge of precipices or climb up winding mountain gorges, and no matter how wild or terrifying the scene, the human figures always seem to belong. Is this why storms by Mu Ch'i never arouse in us that same sense of fury and terror which make Turner's catastrophic spectacles as romantic as Byron's "Childe Harold," which he admired so extravagantly? In the Chinese painting of storms we feel a certain peace and satisfaction in witnessing the communion of man with *22* the elemental forces of nature.

TRADITION AND ORIGINALITY

THE fusion of opposites was not restricted to the conceptions of "Nature, Man and God." A similar approach was applied to historical process. The Chinese have been a remarkably imaginative and inventive people. During each crisis in their history, especially during the period of the "Hundred Schools," and again during the Northern Sung dynasty, they attacked the problems of mankind with the greatest vigor and originality; but at the same time they graciously built upon the past and reworked its principles to meet the new needs of the present and the future. That is why Chinese so-called "traditionalism" has been, in many respects, more baffling to the western mind than either Taoism or Confucianism. We are apt to associate traditionalism with the embalmed spirit of Egypt or the rigidity of Byzantine dogmatism. However, the development of Chinese painting proves that Chinese civilization was really progressive and that it enjoyed a development comparable to the Greek evolution through three stages, the archaic, the classic and the Hellenistic. To the art historian, who uses visualization as his measuring rod, these three steps reveal themselves by three distinctive kinds of representation: linear-planar shapes, plastic volumes and pictorial surfaces. They seem to correspond to successive stages in man's growing capacity to apprehend himself and the universe about him, roughly corresponding to his primary dependence upon intuitional, rational or empirical methods.* At each of these levels of civilization, the mind of man, and therefore his art, seems to change into a new gear. In China these gear shifts occurred during the transitional periods

* The reader should be doubly warned that the author's conception of history differs radically from the usual cyclical theories which have so violently distorted all our speculation about history. By postulating parallel and repetitive cycles of civilization in the various cultures, the cyclical historians have created false, mechanical patterns which have resulted in such absurdities as the equating of the Ch'in and Roman empires; secondly, by using the biological analogy of youth, maturity and old age, the cyclically minded historians have found innumerable triple sequences in history, ranging from the sequence of stone age, bronze age and iron age to the development of early, middle and late in the works of a single artist. Such parallelisms and repetitions by cycles destroy the validity of any criteria of reference. In this study the division of Chinese history into three phases has been founded solely on the basic sequence in man's capacity to apprehend himself and the universe about him.

Philosophically speaking, history results from the interaction of factors of place and of time; one determines the traits of a culture and the other establishes the levels of civilization. On one hand, each work of art is a unique and concrete whole deriving its worth from its own imaginative values and not from its importance in relation to that which went before or that which was to follow in time. In their emphasis on spiritual and cultural values, Froude, Lord Acton and the prophets were undoubtedly closer to the meaning of history than were Bury, Hegel and Butterfield. The cultural values of place are more important than the period characteristics of time.

On the other hand, no one could deny the presence of a very real process of change in civilization. The gradual development from simplicity to complexity, etc., enables the art historian to date his monuments with considerable accuracy. But to equate one process of change with another as parallel cycles is dangerously misleading because the cultural differences so thoroughly modify the common denominators of temporal development; for example, the monochrome landscape of the idealistic period of Southern Sung is unthinkable in the classic age of Greece.

Furthermore, the notion of a repetition of cycles, held by the Greeks and elaborated by the modern cyclicists, is untenable. The so-called West-European cycle of Mediaeval, Renaissance and Modern periods could not be a repetition of the Hellenic cycle because it began with the advanced civilization of the classical

of the Sui and Yüan dynasties, dividing the historical process of change into three phases, the Pre-T'ang, the T'ang-Sung, and the Ming-Ch'ing. With each advance in civilization, the scope of painting was widened. In the T'ang-Sung era the figure painting became less didactic and more humanistic, the depiction of the several arts being a favorite theme; landscape, ink *15* bamboo, and bird and flower painting vied with figure painting in popularity; and the organic *43* principles of nature were investigated—namely, plastic form, the crystalline structure of moun- *37* tains, the various kinds of tree growth, and the relationship of things in terms of scale and seasonal aspects. The fundamental moods of both man and nature were portrayed. In Ming-Ch'ing times the interest in actuality expanded still further to include more casual and every-day themes; the incidental, the unusual, the bizarre and the picturesque became legitimate *28* fields for painting. Scenes were frequently more crowded for the effect of abundance and the treatment was often increasingly ornate. One Ming painter recommended that "the painted figures must be looking about and speaking; the birds should flutter and the animals run; and the spirit must be taken from actual things." The principles of nature were further investigated to include more natural scale relationships, increased continuity of spatial depth through a greater use of ground planes, the movement of surfaces, more tangible atmosphere, *26* and new effects of light. The more materialistic outlook of the Ming-Ch'ing phase meant a greater concern, not with the embodiment of ideas in essential forms, but rather with the sensuous qualities belonging to those forms. The later critics analyzed the difference between Sung and Yüan painting in terms of Sung "li," or eternal principles, and Yüan "ch'ü," or appealing quality. We lack adequate terms to express the subtle changes from the austerity of Pre-T'ang and from the deep tranquillity of T'ang-Sung painting to the increasing Ming interest in feelings, "joie de vivre" and elegance, and to the Ch'ing tendency toward sentiment, *45* exaggeration and prettiness. Since we are not concerned with the development of painting in China but with what makes a painting Chinese, nothing more need be added to prove that Chinese painting evolved through a real process of change from the simplicity, regularity and uniformity of earlier times toward the complexity, irregularity and diversity of advanced civilization.

If this is true, why speak of Chinese traditionalism? Because nothing ever dies out in China. The early traits of the Pre-T'ang age were preserved and reworked to fit the new discoveries of each successive age. This fact more than any other single trait has caused Chinese painting to be the most subtly elusive and difficult painting in the world to understand. Traditionalism and inventiveness went hand in hand. Two illustrations will help to make this more specific. When the T'ang period discovered plastic form, it also encountered the western type of *7* modelling in light and dark in contrast to the Pre-T'ang method of depicting flat shapes by *2*

world and with the highly evolved religion of Christianity. The term ideational, as used in this text, would only be applicable to the art of the Germanic tribes as they emerged from the primitive matrix. That is why the history of European art has been so baffling to the cyclical historians.

Each work of art, and each moment in history, must be apprehended as a unique creation of the inter-action between the factors of place and time—of culture and civilization.

thin bounding outlines. However, since the Chinese disliked the physical corporeality of western modelling, they invented a new method of thickening and thinning "brush" contours to suggest plasticity instead of blatantly describing it. Ever thereafter, "brush" remained the chief means of representing forms. The idea of linear contours was kept alive from the past but it was re-studied to satisfy a new age which needed organic forms to express its more humanistic spirit. What a perfect illustration of the simplicity, directness and immediacy of the Chinese "wedding of spirit and matter." A similar situation arose in Ch'ing times, when the greater interest in actuality demanded the rendering of a kind of rococo movement of surfaces. Once again, "brush" contour was used to convey the undulating movement of the drapery in contrast to the western method of descriptive light, which broke up the surface and the silhouette in the manner of Watteau. No wonder late Chinese painting, despite the discovery of naturalistic principles, seems so far-removed from our own verisimilitude. Like everything else in China, painting had its roots in the remote past.

Therefore, to understand Chinese painting thoroughly, we must know its roots in Pre-T'ang times—that is, from the schematic motifs of the bronzes, from the pictorial remains of the Han and Six Dynasties, and from later copies, such as the two Ku K'ai-chih scrolls. Although these cover two thousand years of development, nevertheless they all belong to the ideational phase of Chinese history. Ideational is admittedly a clumsy term, yet it suits better than any other the mental habit of early artists of intuitively seeking the essential "idea of a thing," in contrast to conceiving things "as they ought to be," or analyzing them "as they appear to be," or distorting them "as we wish them to be." It is almost impossible for us to enter into the spirit and mind of such an age. Appropriately, these early stages of civilization have been called "ages of faith." At such times man has already emerged from his primitive and animistic past, during which nature mystified and overpowered him. Although he is no longer enslaved by magic, he still depends on intuition, imagination and revelation to guide him rather than on reason or experiment. Beliefs are based upon a power or powers, greater than human. To put it another way, heaven rather than man or earth was the ultimate reference for experience. Even Confucius, who seems so confident of man's own ability, referred everything to presuppositions concerning the legendary rulers. Since logic did not appear until T'ang times, thinking was pre-logical and, as in Greece, coincident with the creation of plastic forms. Neither the Confucian classics nor the Tao Têh Ching present any orderly system of explanation; they wander along from one intuited truth to the next, each made vivid by concrete images from experience or by poetic overtones, since ideational thinking avoided abstract terms and lacked the clear-cut precision of logical definitions. Understanding was based upon a priori principles which were often reached through analogy. Lao Tzŭ observed that water is the softest substance and yet that paradoxically it will wear away rock which is the hardest, and from this naive observation, principles were derived which ranged from a laissez-faire ethics to non-resistance toward adversaries. Philosophy in the complete sense of that word had not appeared. Taoism and Confucianism were doctrines of living rather than philosophical systems; that is, they dealt with the essentials of experience rather than with its totality.

Thinking was also pre-scientific. It is impossible for us to imagine ourselves back in an

age when a beyond-the-natural explanation of any event was instinctively preferred to the natural cause. If we tripped at a door we would never suppose that a demon had tripped us nor would we, like Ku K'ai-chih, imagine that a bamboo leaf could make us invisible. Although these cases may seem like survivals of magic, they also show that ages of faith lived in closer contact with the realm of the spirit than have rational or skeptical ages. We all know how hard it is for us today to accept incomprehensible truths or to give ourselves up to the inwardness of meditation. Triumphs of the intellect may tell us more and more about the outer world of sense and knowledge but will never reveal the inner reality of spirit or the secret of living. Indeed, reason and scientific knowledge, while enlarging the scope of the imagination, may often separate the artist from the inner reality which is his goal, unless he makes them his servants. We value Uccello for his color pattern and not for his "dear perspective," which often put the Renaissance imagination into a strait jacket. Rembrandt had to obscure the visual naturalism of his period by the mystery of his luminism in order to reveal the depths of the human soul.

Now it is the merit of ideational art that the basic "idea" and the form are inseparable. While looking at the famous "Toilet Scene" in the style of Ku K'ai-chih, we feel that it is *4* no ordinary scene, not because it conveys the moral precept that "many know how to adorn themselves but few know how to adorn their souls," but because the painter has caught the essence of the idea in an ineffable way. Irrespective of the increasing knowledge of natural principles in later periods, the Chinese never forgot their roots in the ideational past. They continued to value intuition and imagination above the tools of reason or empirical method. The T'ang painters may complain that the Pre-T'ang masters sometimes represented "men larger than mountains," yet they praised the purity with which the earlier men realized the spirit of things. Chang Yên-yüan wrote: "In ancient paintings the trace is simple, the idea is tranquil (tan), and they are elegant (ya) and correct (chêng)."

Although the spirit of early painting may seem to elude us, the mechanics of the pictorial language can be clearly formulated. Historically speaking, the test of earlier or later visualization is whether the imagination is concerned solely with the idea or more with its physical appearance. In Pre-T'ang painting, since the mind dealt with the ideas in their essentials, the result was an ideographic image of the thing rather than a descriptive likeness. The psychology of such visualization is what we all experience when we picture an object as an idea. Call to mind the idea of any object, for example a horse; instantly, that object will appear as a flat *3* profile before the mind's eye, right there, *en face*, isolated against a void; shape alone is adequate to identify the idea of anything. Shape is more primary than plastic form, color, texture or any other quality. Since shape is defined by bounding contour lines, early painting consisted of planar motifs depending for their effect primarily on linear rhythms and on area relationships. The painter told his story in a succession of shapes isolated against a void background. The composition was additive—that is, it ran along in time, and it depended *1* upon the spacing of areas and intervals and upon harmonic repeats of shape for unity. Since the artists were interested in essentials and not in the profusion of actuality, the pictorial motifs or abstractions tended toward simplicity, uniformity and regularity. Except for their

[27]

symbolic attributes it would be difficult to distinguish between ruler or ruled, male or female, young or old, scholar or soldier, and so forth. These mechanics of ideographic visualization set the limitations within which the creative imagination must work. Portraiture, since it requires close observation of the particular, will fail in early times to reveal the personality of an individual. Landscape, since it needs space and scale, will be ineffective, so that in Pre-T'ang landscape "the water was not extensive enough to allow anything to float upon it." The painting of animals, birds and flowers, since they depend so much upon textures, will fail in sensuous appeal with the result that the Han painters found it "easier to draw imaginary creatures than dogs and horses." To our eyes, accustomed to representational fidelity, a pictorial language of linear and planar motifs lacks all the qualities of actuality—plasticity, texture, natural color, scale, space and light; however, to explain these conventions in terms of primitive mentality or child psychology is to completely falsify the capacities of an ideographic age. Confucius and Lao Tzŭ were neither primitive nor childlike in their thinking, and Ku K'ai-chih had the cultivation of twenty centuries of development behind his style; all three were products of an era in which the mind of man approached experience more by intuition than by reason, more by imaginative analogies than by formulated concepts. Men still enjoyed the feeling for awe and ecstasy, and for wonder and mystery; these were the emotions which quickened the content of ideational painting. The breath of the spirit sings through the flaming rhythms of the Han lacquers and the Wei reliefs with a poignant immediacy, not to be found in more idealistic painting nor in more imitative description, and not to be belittled by the theory of "memory images." Two thousand years earlier, naive primitive shapes may have been prompted by animism and produced for their magical efficacy, but ideational thinking, together with its ideographic pictorial language, should never be confused with neolithic origins. One might just as well equate a developed theology with primitive magic. Ideographic pictorial language was a highly evolved means to express an intuitive approach to the essential spirit of things. It remained the source of many of the most striking characteristics of
34, 8 Chinese design, namely: the preference for linear rhythms, the isolation of motifs, the rela-
39, 44 tionship of areas, the importance of voids, and composition in terms of time.

In view of the obvious limitations of the ideational approach to experience, it may seem that an undue emphasis has been put upon these origins. However, the uniqueness of Chinese painting depended in large degree upon the re-working of early principles to meet later needs. In our western civilization, the attitudes and principles of the past sloughed off with each new age; in the Greek development, archaic lines and planes were forgotten except in moments of conscious archaism; and the Renaissance men considered the Middle Ages so inferior that they labelled the art Gothic. In China alone new principles of nature and new principles of art were discovered without sacrificing continuity with the past. Suppose Raphael and Tiepolo had retained memories of the spirit and simple directness of Giotto and, at the same time, had conveyed Renaissance "humanism" and the larger unity of the Baroque. It is difficult for us to imagine such a blending of past and present, and yet something comparable to that is exactly what the Chinese achieved.

IDEALISM AND NATURALISM

WE are now in a position to appreciate the Chinese blending of these two European extremes, naturalism and idealism, using naturalism in the sense of an interest in "things as they appear to be," and idealism in the classic sense of "things as they ought to be." One is concerned with the concrete and particular, the other with the general and typical. They represent two kinds of quest after truth and beauty, one in the sensuous appeal of actual nature and the other in the intellectual satisfaction of perfected nature. The Chinese shunned extreme naturalism, although, paradoxically, no artists ever spent so much time in contemplating the natural world; on the other hand, they distrusted extreme rationalization, although they insisted, more than any other people, on the value of learning for creative effort. The natural and the ideal were fused together in the ideational "essence of the idea." As Ch'êng Hêng-lo put it, "western painting is painting of the eye; Chinese painting is painting of the idea." His statement would have been complete if he had added, "of the idea and not of the ideal."

To what extent have the Chinese painters moved our senses? Certainly the Chinese loved things; the furniture, the screens, the potteries and porcelains are all fascinating works of art; the lowliest object is a craftsman's delight; the smallest detail shows both elaborate care and creative imagination. No other people, except the Japanese, have lavished such attention on the featheriness of birds, the furriness of animals, the intricacies of insects, the rhythms of *41, 38, 46* plants or the textures of rocks. However, in spite of all this, our pleasure in the Chinese render- *42, 26* ing of physical qualities seems to be more intuitive than sensuously emotional. In fact, one might almost say that it remains virtuous. By contrast, our delight in the physical in European painting embraces the attraction of things, exotic and extravagant combinations, and the intoxication of pure sensation and western critics have sung the praises of "tactile values," color vibrations, and richness of effect.

In China sensuous effects were conditioned by obedience to natural principles and were limited to the expression of the "essence of the idea." The contrast between east and west may best be illustrated by the painting of still-life. For us, because still-life has been chiefly an expedient for studying sensuous and design effects, we have felt free to make combinations of diverse objects, fruits, flowers, and fish or game, utensils and works of art, anything, in fact, provided the appeal to our senses was stimulating. Ordinarily, the Chinese refused to combine objects except according to their natural habitat and associations. Plants were linked with their appropriate birds, for example, quails with millet; animals must have the correct environment; aquatic creatures belonged together; everything had its proper season. Even the great Wang *34* Wei was criticized for his poetic license in having painted a banana plant in snow. The birthday rebus, made up of homonyms, was the one exception to the strict adherence to natural associations. When these are violated by western painters, our attention may be forcefully directed to sensuous effects, while the Chinese selective emphasis on certain natural combinations tends to arouse our intellectual delight in the recognition of those relationships. *37*

This drift toward intellectual rather than sensuous appeal was further intensified by the

Chinese habit of entering intimately into the lives of non-human forms of being. Just as the Chinese painter communed with landscape, in similar fashion he lost himself in the realms of plant, animal and insect life. How foreign to the western mind this Chinese approach seems! Only the French entomologist Fabre, in his life of a moth or a mason bee, has been able to transport us out of our man-interpreted world into the existences of other creatures. This was not a relationship of identity as in India, where the doctrine of transmigration established a hereditary link between the human and the animal. In China it was a matter of sympathetic communion, which created a desire in the artists to experience the other realm of being. The same psychology applied to flowers. When the Chinese painter planted a flower, tenderly nourished it through its life, and finally painted it after its death, what did he paint? Certainly not the same thing which a western painter seeks when he paints a still-life of the flower before him. The western flower will appeal primarily to our senses; the Chinese painting of a flower will invite us to share in its life, which is both an intuitive and an intellectual experience.

In the rendering of sensuous qualities, a similar contrast may be seen. When a Chinese paints fur or feathers, we feel that textural quality was not the painter's goal but that furriness or featheriness were essential traits of the animal or bird. This may sound like hair-splitting of the most minute sort but the difference in our reactions is unmistakable. Technically it may be due to the Chinese rendering of each hair or feather as a separate ideational motif instead of the western optical illusion of fur or feather textures. At any rate, the result was decidedly less sensuous.

The Chinese also had a different approach to ornateness, lavishness and enrichment of all kinds. Until we have lived with Chinese paintings, we seldom stop to think how great a role splendor has played in our traditions, whether the jewel-like enrichment of altarpieces to the glory of God or the extravagant display of courtly "pomp and circumstance." From the cosmic conception of the Son of Heaven we would have expected the Chinese to exceed us in lavishness. Quite the contrary was the case; the T'ang and Sung emperors were portrayed with simple dignity while courtly magnificence was not allowed to invade the paintings, except during a brief period of inferior taste in Ming-Ch'ing times; courtly scenes, no matter how elaborate the actual ceremonies may have been, were seldom distinguishable from everyday episodes. To the Chinese, sensuous beauty resided neither in richness of effect nor in physical appeal, but in elegance, refinement and discrimination. The appeal to the senses was ever tempered by the activity of the mind.

Just as the Chinese knew nothing of the naturalism of the west with its sensuous interests, they also were innocent of western idealism in its classic and neo-classic forms. This kind of idealism stemmed from the Greek devotion to reason as an instrument for attaining the perfect and the beautiful. Because the Chinese depended more upon intuition and imagination than upon reason, they attacked the problems of the ideal from a different angle. We have already considered how Wu Tao-tzǔ rendered the plastic organic forms of the west in terms of brush. This was the moment in Chinese history when thinking was beginning to be more

conceptual, but what a contrast between the two ideals; the Greeks attempted to rationalize the perfect in terms of mathematical proportions and generic types; the Chinese tried to convey the motivating spirit of the type, thus preserving the essence of the idea and at the same time presenting organic completeness. Is this why idealism in the west gives to painting a remoteness from immediate experience as though the forms existed in a charmed realm of perfection, whereas intellectualization in China never lost its contact with nature until the introduction of Ch'ing mannerism? The Chinese did not push reason to the extreme of the rationalized type illustrated by the story of the Greek painter who painted an Aphrodite by blending the best features of the beautiful maidens who passed before him; the Chinese sought the universal in the particular without losing the distinctive character of that particular, as indicated by the story of the painter who studied a single flower throughout its life.

The contrast between east and west centers in the role of reason in art. Ever since the rise of romanticism and expressionism we have thought of painters as men of feeling rather than as thinkers. The budding genius is generally warned against going to college lest he dull his inspiration with too much analysis and lest he degenerate into an art critic or an art historian. To think about something seems alien to the creation of something. Theories about dynamic symmetry or the geometry of design would have been abhorrent to the Chinese painter with his Taoist love of freedom and effortlessness. Notwithstanding, there can be no doubt about the importance of intellectual life as one of the first requisites of the painter. The scholar and the painter were one in China. This challenging situation was made possible only because of the humanistic nature of Chinese scholarship and because of the gentlemanly character of Chinese painting. Even Confucius, who turned to knowledge as the answer to life's problems, insisted that the scholar must not be an instrument—that is, a specialist, and claimed that his interests must be wide and humanistic. The Chinese painters prized cultivation above information. "You can leave the books that you do not like alone and let other people read them." They also placed experience above reason. The Chinese painter would not have said, "I think, therefore I am," but rather "I experience, therefore I create." Rationalization in connection with creation was contrary to the deepest cultural instincts of the Chinese. In Greek idealism the mind was satisfied by clarity, order, and the finality of a perfect norm; in the Chinese creation of types during the T'ang-Sung period the imagination was stimulated by suggestion, tension and the mystery of the essential spirit. Although Chinese painting has the *10* intellectual qualities of scholarly cultivation, it leaned not upon reason but upon reflections about experience.

Emotionally, we think of classic idealism as calm, serene and lofty, terms which we might apply to Chinese painting if comparing it with modern expressionism; however, confronted by classic idealism, we suddenly realize the dynamic and exciting qualities of Chinese painting. No one would ever picture a Greek or neo-classic painter as attacking a wall "like a demon," in the manner of Wu Tao-tzŭ, nor as indulging in scholarly play with ink. *13*

Moreover, the Chinese did not attempt to rationalize the beautiful; that is, they did not

explore the western concept of the beautiful as a supreme value, associated with the good and the true. Beauty, when considered as a separate aesthetic delight, was called a flowery embellishment, which was quite secondary and which might be definitely harmful to the essential spirit. In China formal beauty was not isolated but resided in the whole content, and therefore the Chinese do not speak of beauty or aesthetic value but of the spirit, or ch'i.

STYLE

INTRODUCTION

In our quest for what makes a painting Chinese, the quality of pictorial form seems even more elusive than the character of the content. We seek in vain for terms which will suggest that union of the vital and the abstract which is so vividly present in Chinese pictorial motifs. To apply the terms "ideal," "life-rhythm" or "self-expression" to Chinese form is quite as misleading as to attach "subjective" or "romantic" to Chinese content. It is an axiom of art history that design values, like everything else in life, depend upon the basic orientations of each culture toward experience. Since the Chinese avoided the western approaches to the mystery of artistic creation, either through science which investigated the mechanics of representation, or through aesthetics which questions the nature of the beautiful, or through psychology which explores the motivations of expression, the terms used by us to define the essential qualities of painting, such as unity, balance, scale and empathy, together with the aesthetic types of the beautiful, sublime and so forth, are all slighted in Chinese critical writings. In their place, the Chinese employed terms taken from the associated arts of poetry and calligraphy, or, when specifically trying to express the inexpressible of painting, they resorted to the terms of mysticism, which is as it should be. Furthermore, ideographic language was unsuited to exact definition and might be called the script of the imagination rather than the "tool of reason." For example, in expressing the principle of the "one and the many" by which the Tao manifests itself simultaneously everywhere, the Chinese will resort to the poetic simile that the moon reflects itself in ten thousand streams. Consequently, in this analysis of how the Chinese attempted to paint the spirit of the Tao, we must use Chinese terms and must examine each conception with care, lest we read western connotations into the English translations. To the Chinese truth is not truth unless it is subtle and these principles of artistic creation excel in subtle elusiveness.

CH'I OR SPIRIT AND ITS FRUITS

THE word ch'i, or spirit, summed up the presence of the Tao in painting. If an artist caught
40 ch'i, everything else followed; but if he missed ch'i, no amount of likeness, embellishment,
skill, or even genius could save the work from lifelessness. How shall we come to grips with
ch'i? The Chinese themselves have written exhaustively, trying to define this inner mystery
which for them held the secret of artistic value. In the Pre-T'ang ideational phase of history,
Hsieh Ho used the famous but vague phrase ch'i-yün shêng-tung (spirit-resonance life-move-
ment), but by the time Sung humanism and philosophy dominated thinking, ch'i became an
isolated concept in Ching Hao's list of the "Six Essentials" of painting, and was finally
identified with the Tao by Han Cho when he said that "painting works with the 'creative
forces' and shares the same spring as the Tao." In other words, the spirit of art was identified
with the spirit of the universe. Every artist, east or west, seeks the reality behind the appearance,
but his quest is colored by his approach to spirit and matter. How completely the western
writers have missed the conception of ch'i is shown by their translation of it as "rhythmic
vitality." In the phrase ch'i-yün shêng-tung, the second half, "life-movement," is the result
of "spirit-resonance." The western critics were so accustomed to emphasize the material
manifestation as the means toward the beyond-the-material that they missed the Chinese
insistence, first on the spirit and then on the form. When Chang Kêng called ch'i-yün the
"moving power of heaven which is suddenly disclosed" and claimed that "only those who are
quiet could understand it," he was dealing with the three essentials of a mystical experience,—
the absolute, meditation and illumination. "In painting, ch'i-yün grows out of the wanderings
of the heart; it is obtained through the inspiration of heaven." It is not born of the genius
of the artist who is only the instrument of heaven. Wu "concentrated his spirit and harmonized
it with the working of the Tao." The Tao is made manifest in art as ch'i, and ch'i, being spirit,
can only be known by its fruits. Although the Chinese never listed these fruits, they constantly
returned, in their discussions of the presence of ch'i, to a few basic notions, namely: naturalness
(tzŭ-jan), effortlessness (i), universal principles (li), "bone-means" (ku-fa), structural strength
(shih), pictorial reality (shih), seasonal aspect (ching), life-movement (shêng-tung), brush
(pi), and ink (mo).

NATURALNESS (TZŬ-JAN) AND EFFORTLESSNESS (I)

THE most definitive fruit of ch'i was its self-existent quality or naturalness, whose source we
find in Chapter xxv of the Tao Tê Ching:

> "The Ways of men are conditioned by those of earth,
> The ways of earth are conditioned by those of heaven.
> The Ways of heaven by those of the Tao.
> And the Ways of Tao by naturalness (tzŭ-jan)."

To become an instrument for conveying this naturalness of the Tao, the artist must attain the

fruit of effortlessness. This meant much more than spontaneity or even than personal genius, since it was born of the harmony between the artist and universal spirit, which is akin to mystical union. Chinese writings abound in phrases and stories about the preparation of the artist in order to become attuned to the universe with its unfathomable thoughts (shên-ssŭ) and its unnameable ideas (miao-i). Every age insisted upon the necessity of meditation and concentration in order to reach the highest state of creative readiness; then the artist could "grasp the natural without effort." In his analysis of the presence of ch'i in the actual process of painting, Ching Hao said:

> "Heart follows, brush executes,
> Selects forms without doubt."

In all great art, effortlessness is linked with inevitability. Just as the music of Mozart, flowing along from like to like or to direct contrast, could never be otherwise, the greatest Chinese painting evolves naturally, effortlessly and inevitably.

LI OR UNIVERSAL PRINCIPLES

WHEN the Chinese tried to explain the mysterious reality of art, they spoke of li, or the universal principles behind everything. Since this was the same term used by the Neo-Confucianists to indicate the operation of the Tao in the realm "above form," some critics have likened the li to the Greek "ideas." We have already discussed what different results the two conceptions produced in the emotional and aesthetic character of idealistic Greek art and Chinese painting. How did the contrast show itself in form?

In appearance the Chinese forms, which were based on the li, were more abstract than the Greek ideal forms and yet rhythmically closer to nature, "like nature, not in form but in operation." The living quality of the western ideal type depended upon plastic organic form, which was removed from nature by its perfection, while the vitality of the Chinese form stemmed from the rhythmic flow of the brush contours, which, by virtue of their abstraction, suggested the non-physical. Both the li and the Greek "ideas" concerned universal principles but they differed in emphasis. A knife consists of a handle and blade, while its function is to cut. Although these two aspects were recognized both in the east and in the west, the Greeks would have emphasized the generic type of knife as a handle-blade idea, while the Chinese would have concentrated more upon its cutting quality. To the Chinese the essential truth about a willow tree is its swaying suppleness, the li by which it has its being, and that essential was not to be compromised by speculating even about the general character of willow tree. The notion of the li certainly demanded truth to natural principles but it also involved a further penetration into those principles to seek the essential spirit of the idea.

As so often in Chinese thinking, a star cluster of principles were associated with the li, all dealing with the general conception. Only three need to be mentioned. Chang Yên-yüan spoke of the "directing idea" (li i), which apparently referred to the controlling motivation of the painting. Ching Hao introduced the collateral principle of "thought" (ssŭ), which meant the omission of everything except the great essentials. This was a selective principle

according to which all temporal and incidental qualities were stripped from the idea and all descriptive accessories were to be eliminated until the stark reality of its essence remained.

9 For example, in the famous Sung painting of a Ch'an monk chopping a bamboo stalk with a knife, every stroke in the painting suggests the "idea" of chopping. Lastly the Chinese spoke of the artist's conception (i), the transformation of the idea in the hands of a specific painter who was the instrument for conveying it. "To express an idea or to represent an object properly, it must be turned over and over again in the mind, until it unites with the soul."

From this résumé of the fruits of ch'i which related to the conception, we perceive that

42 Chinese painting was destined to become an art of extreme elimination, simplification and suggestion. How will such conceptions be realized in pictorial language? The remaining representational fruits of ch'i concerned that problem. The first two, ku-fa or "bone-means," and shih or structural integration, concerned the structural organization of single forms and whole compositions; the next two, shih or pictorial reality, and ching or seasonal aspect, attacked the mystery of the independent life of pictorial forms; shêng-tung or life movement dealt with the nature of rhythmic movement; and the last two, pi or brush, and mo or ink, were the chief pictorial means of the scholar-painter.

KU-FA OR BONE-MEANS

In the earliest formulation of the fundamentals of painting Hsieh Ho listed ku-fa yung pi, literally, "bone-means use brush," second only to ch'i or spirit itself. Ever thereafter, structure through brush remained the basic method of the Chinese for making the spirit pictorially manifest. This truth cannot be overestimated since it fixed the visual character of Chinese painting: calligraphy and painting became so thoroughly twin arts that painting looked more like our drawing; all the visual qualities most admired by us, color, plasticity, texture, weight, and physical stability, were subordinated to inner structure. In speaking of the brush strokes

5 which set up this structure, Hua Lin said: "Although these few strokes may be entirely covered up, the painting must have their strength to stand up; otherwise, even scarecrows would have the forms of men. Could a man be a man with no bone?" That this ku-fa or bone-means did not refer to anatomy, as Giles translated it, is attested by its use in the fifth century in connection with flat, two-dimensional shapes which did not even possess plastic solidity, much less anatomical knowledge. It was a pictorial principle, referring to the rhythmic structural ensemble.

Another proof of its freedom from representational interest was its application to the

46 abstract art of calligraphy which required ku-fa. In fact, none of these fruits of ch'i dealt with representational knowledge, such as anatomy or perspective, but were truly fruits of the spirit. Chang Yên-yüan referred to bone-spirit (ku-ch'i), and Han Cho spoke of structural essentials (t'i-yao) in contrast to terms used for the mere representation of form, such as form likeness (hsing-ssŭ) or formal resemblance (hsiang-hsing). To the Chinese, trained to value the structural "ku" of brush strokes, our modelled plastic forms seemed blatant and vulgar: the T'ang men revolted against the Graeco-Indian "ideal" forms, and the Ch'ing painters called the

Baroque paintings the work of unimportant artisans (chuang). To them any good craftsman could make a fair copy of natural forms, but why call it art? Confronted by chiaroscuro and cast shadows, one Ch'ing critic tauntingly inquired whether Europeans were half white and half negro, since they painted faces with one side dark. The only concession to western painters was that "students of painting may well appropriate one or two points from them to make their own paintings more attractive to the eye." Even if these Chinese had seen paintings by Michelangelo instead of by Castiglione, the representational values would still have blinded them to the inner reality, just as we, until recently, have found it difficult to realize the structural truth to nature in a few Chinese brush strokes.

In landscape painting bone-means (ku-fa) was tied up with the wrinkles (ts'un), which caught the crystalline structure of the mountains. Observe how the spirit of the mountain *17* lives in its silhouette and how this rhythm is repeated in wrinkles throughout the structure. Even the shaded parts are rendered by a multiplicity of wrinkles which lend structural character to the dark passages. Instead of plastic form through light and shade, the Chinese achieved structural form through "brush." We in the west have depended upon the qualities of solidity and weight to reinforce plastic form, and unity owes much to the physical integration of the solid. To our eyes a Chinese form often seems reduced to a kind of ideographic skeleton. A *10* few brush strokes may suggest volume but they certainly fail to convey the through and through sculptural mass of modelled form. By Yüan times the painters were said to write out their landscapes in idea writing (hsieh i), and painting took on the delights of calligraphy. *25* The danger in this was that form might become a mere pattern of abstract brush strokes as it sometimes did in the lesser efforts of the "literary man's" style.

SHIH OR STRUCTURAL INTEGRATION

THE term, shih, has been variously translated and interpreted. It certainly concerned structural relationship and was employed by the Ming-Ch'ing painters in the sense of structural cohesion. Faced by the increasing irregularity, diversity and complexity of their period and confronted by the tendencies toward overcrowding and disintegration, these men were especially troubled about holding the whole structure together. Chao Ts'o devoted a long passage to this problem: "In painting large landscapes the principal thing is to obtain shih or structural integration. The reason why we value capturing the 'shih' and spreading the ching (seasonal effects) is that (the painting), when looked at as a whole, appears as if done with one breath, and, when studied carefully, it is also in harmony with the spirit (shên) and the principles (li)." From this comment it is clear that we are dealing with a fruit of ch'i, as stated by another Ming writer: "One may say that the breath of the spirit (ch'i) is in the shih." *30*

In a passage by Tung Ch'i-ch'ang, the same problem of the structure of the whole design was succinctly stated. "After the outline of the mountain has been decided upon, only then put in the wrinkles (ts'un). People, today, start with small parts and build them up into a big mountain. This is a most serious fault. When the people of ancient times composed a large *17* picture, they used three or four great divisions; thus they achieved a design of the whole

although it contained many fine details. In a word, the most important thing is to capture the shih." This explains how the Chinese painters could maintain breadth of design even though they painted in the fine style (mi) with its minutiae. When western artists like the Van Eycks painted every hair, they were inclined to lose the larger structure which in China was preserved by the proper attention to shih. Shên Tsung-ch'ien insisted that, "if the shih is not sufficient, one should lay down the brush."

When applied to a single feature, a tree, a rock or a figure, this quality of indeterminate structural cohesion was tied up with posture, which is another translation of shih. In the passage above, Chan Ts'o used it in this narrower sense. "If you have shih in painting a tree, then, although the tree may go this way and that and may thrust forwards and backwards, yet it is perfectly poised; if you obtain shih in painting a rock, then, although it may appear grotesque, yet it does not lose the li (principles); even if they seem to be ordinary, they are not mediocre."

The meaning of shih may be further studied in the principles of posture, used in ideographs. Let us consider the simplest problem of the square ideograph signifying mouth (k'ou). How can it be transformed from a static geometrical figure into a shape with a distinctive structural life? The answers to that question embrace the fundamentals of brush-stroke relationship. Each stroke has the touch of the artist; each stroke has a character of its own, whether thick or thin, straight or curved, blunt or tapering, short or long, and so forth; the combined strokes establish a shape which has its characteristics of breadth, height, spread, contraction, density, emptiness, poise and balance; finally, the interacting forces of the various strokes and the intervals between them create tensions which must be held in equilibrium. Although these four aspects of an ideograph cannot be separated, shih referred primarily to the structural shape. In the square ideograph no lines would be treated in the same way and no two parallel lines would be of the same length; the result would be a dynamic square shape with a distinctive structural character. Such a square would have shih. We can discern now, how the insistence on structural integration would affect Chinese pictorial motifs.

SHIH OR PICTORIAL REALITY

In contrast to the structural essentials of bone-means (ku-fa) and structural strength (shih), the next two fruits of ch'i go into the problem of how the Chinese could make their structural, non-plastic forms more convincing in appearance. Again, these fruits did not refer to outward representation but to a sense of aliveness or pictorial reality (another shih). "This shih is something that catches ch'i and presents the living quality of the thing, and this is what is meant by 'ch'i-yün shêng-tung.'" Shih has generally been translated reality in the sense that it is present when the artist comes to grips with reality. Originally it meant "seeds" and now is translated substance; therefore, in critical writing, it has been contrasted with "embellishment" in the favorite literary opposition of fruit and flower—"fruit is the foundation, flower the outer extremities." None of these translations quite conveys the meaning of shih, which is the quality of having a life of its own. Aliveness or vitality might be used, if we kept in mind that the aliveness belongs to the work of art in its own right and not to the lifelike

representation of any object in nature. Rembrandt, in his drawings, had more shih than any other artist in the west, not because he imitated natural effects but because his pictorial forms, even of inanimate objects, were tremendously vitalized by a life of their own. In fact, too much descriptive realism is the surest way to make a work go dead, as can be seen in the Maruyama School of Japan or in the Ch'ing artists who painted every hair most meticulously. Indeed, it is surprising that the practice of the fine style (mi) did not lead more often to the loss of shih, and it is just another proof that as long as the artist held to the goal of ch'i his work would bear the fruit of shih regardless of whether his style was painfully fine or sketchily free. However, the recent introduction of scientific knowledge from the west has been like a kiss of death to Chinese painting whenever our representational solidity has taken the place of pictorial substance. The figure of Li Po by Liang K'ai barely touches the ground and yet *10* the whole form seems to be the epitome of *élan vital*; and although the ladies of Lêng Mei never really sit on their chairs, they breathe an air of relaxed elegance. They have shih. This was the secret of the greatness of Giotto; his sacklike forms were corporeally unconvincing and his poses and gestures were frequently clumsy, yet his figures emanated a mysterious power, the presence of the spirit in flesh, which was so lamentably lacking in his followers. This awareness of a presence should not be confused with the emotional situation. The shih can be hurt by too much expression of emotion as well as too much naturalism. Western so-called expressionists have been the chief offenders in this respect because they have exaggerated the emotional effect in the misguided hope that it would make their art more spiritual, and because in bad expressionistic art the artist has expressed his own emotions instead of allowing the images to carry their own message. Both of these mistakes were very rare in China, so that the most violent scenes, such as that of the monk chopping up the statue of Buddha to make a warming fire, never became expressionistic, because the painter restricted himself to the substance of the idea which gave to his forms their own independent life.

The meaning of shih may be further refined by examining its relation to li or the eternal principles. In the statement that "one must go on until the shih and the li do not harm one another," we see that shih was a means "below form" to realize the principles "above form," and that if one got too much shih the principles would be obscured, and if one got too little shih the principles would not be revealed. "We are faced with the relation between type and actuality." This raises the puzzling problem of the effect of theorizing on the living quality of art. Just as the search for an ideal beauty resulted in the form types of Greece, the quest of the li principles created a language of types in China; although this eventually ended in the stereotyped forms of the late encyclopedias, it is amazing how little the shih was injured during the great periods by the degree of intellectualization needed to establish standard types *9* —of figures and their drapery folds, of trees and rocks, and of fur and feathers. Assuredly each *18, 38, 41* great artist invented his own types and also leaned very heavily on his predecessors, having founded his style on copying the styles of the past. In view of the swift demise of Raphael's "ideal forms" in the hands of the Mannerists, what was the source of lasting vitality in the Chinese "standard forms"? In their inception, the artists were not seeking perfect beauty or a

proportional norm, but they were striving for an inner reality which gave the object its reason for being. Therefore, forms, no matter how intellectualized or standardized, which issued from the source of aliveness retained the power to suggest an air of shih or pictorial reality.

CHING OR SEASONAL ASPECT

In landscape what will evoke this quality of inherent life? Ching Hao included it in his "Six Essentials of Landscape Painting" and called it ching (misleadingly translated scenery). The purpose of ching was "to fashion according to the seasons and to study the mysteries to create truth." This passage deals with the method of making landscape convincing, not by describing its physical appearance, the plasticity of rocks and the continuity of space, but by sensing the truth of its mood according to the laws of seasonal change. If we feel the moods of the season, weather conditions and time of day, the landscape will convey a real experience. Kuo Hsi said, "The spring mountain is wrapped in an unbroken stretch of dreamy haze and mist, and men are joyful; the summer mountain is rich with shady foliage, and men are peaceful; the autumn mountain is serene and calm, with leaves falling, and men are solemn; the winter mountain is heavy with storm clouds and withdrawn, and men are forlorn. . . . The sight of such pictured mountains arouses in man exactly corresponding moods. It is as if he were actually in those mountains. They exist as if they were real and not painted."

SHÊNG-TUNG OR LIFE-MOVEMENT

This fruit of ch'i is the equivalent of rhythm in western painting and is fraught with all the extension meanings associated with that word; indeed rhythm is often used synonomously with art itself. Both shêng-tung and western rhythm concern the fusion of variation and order, of movement and measure, and of vitality and stylization; also they involve suggestion, repetition and fluency of design. The Chinese approach to these problems is belied by the term life-movement since that word implies an emphasis upon natural rhythms. We must never forget that spirit-resonance (ch'i-yün) was the source, and life-movement (shêng-tung) was the result. "When men are of a high class, the spirit-resonance is high; it is inevitably followed by life-movement." The rhythmic quality originated in the transforming power of the imagination.

To understand how shêng-tung differed from western rhythm, we must ask what kind of movement and what kind of measure were valued. This may be made more concrete by contrasting the favorite inspirations for the study of rhythm in the east and in the west. Most western artists have claimed that the study of the nude was the best training for drawing anything else—whether landscapes, animals or still-life. The Chinese often reversed this advice, saying, "those who want to do figures must first do trees and rocks." These two choices signified deep cultural preferences. In practice the European artist has been trained in the fundamentals of rhythmic relationship by drawing the human body; the Chinese painter has been trained on ink bamboo, the pictorial sequel to his childhood discipline of writing ideographs. The contrast could scarcely be more striking. These two kinds of training

[40]

differ in all the ingredients on which the feeling for rhythm must depend, namely: organization, linear movement, solidity, stability, mobility, equilibrium, and expressive character.

In organization, the human body is a uniform organism of integrated head, torso, two arms and two legs; instead of uniformity each bamboo presents an ensemble, unique in the number, size and relationship of its parts since the shape of each plant has resulted from the struggle to adapt itself to a special environment. In a human body, orderly system resides in the shape of the whole organism and variation lies in the parts. In a bamboo, repetitive order arises from a uniform principle of growth by which the disposition of the leaves of a single twig will reveal the laws of the behaviour of the whole bamboo, and variation results in the ensemble from the struggle for light and existence. Consequently the problems of rhythmic sequence were reversed. The Chinese painter had to relate many similar motifs of stalks and leaves in an irregular and asymmetrical pattern instead of integrating the dissimilar units of the body in a form which never loses its relatedness, whatever its pose.

Furthermore, the rhythmic curves of an animal organism and of a growing plant arise from vitally different functions. In one, the artist must concentrate upon the highly complex contours of muscles, each part of the body demanding separate treatment, and, at the same time, find repetitive harmonies in this complexity and diversity; in the other, the contours of a stalk or leaf are much simpler and are multiplied over and over, but the artist must seek the vitality of growth in their sequential relationships.

This contrast was intensified by the western passion for solidity and the Chinese tendency toward planar silhouettes. A nude is a cylindrical solid made up of the thrust and counter-thrust of volumes, and therefore the artist tries to make his rhythms model the form in foreshortened lines which approach and recede like the sinuous curves of the muscles themselves. A bamboo is a study in branches shooting up toward the sun and in leaves silhouetted against the sky, and therefore the artist concentrates upon the springing movement of growth and the broken interplay of leaves in lateral movements.

Under such divergent training in visualizing rhythm, the west was destined to excel in figure painting and the east in rhythms derived from nature. A European will tend to paint trees so solidly that they often violate the actual visual experience of nature according to which the volume of a tree appears to flatten out into a linear pattern of trunk and branches against 23 the void of the sky; that is what the Chinese painted, omitting the foreshortened branches and bringing out the lateral relationships. In such a field of scattered motifs, the voids between them counted equally with the branches and leaves in creating rhythmic sequences, whereas in the rendering of a solid compact body the painter must concentrate upon the continuity of solid forms with less attention to the voids between them. To draw an arm solidly is more important than to depict its distance from the torso; but in bamboo painting the spacing of leaves and branches is all-important.

On the other hand, we feel that the Chinese have been limited in their handling of the human figure both by the omission of the nude and by using the rhythms of nature in their rendering of drapery. To represent the rhythms of the female form by the graceful lines of

a weeping willow will surely miss the vital sensuousness of a beautiful body, and consequently paintings of Yang Kuei-fei at her bath seem very feeble in organic solidity. In like manner, we are apt to be disturbed by the use of drapery conventions which have been inspired not by the form beneath the drapery nor by the material itself, but by association with rhythms from nature, indicated by the names of the various rhythmic strokes, such as bamboo leaf, broken reed, or angleworm drapery. By this device Chinese figures took on qualities of movement akin to those of nature even when the forms themselves remained relatively immobile.

The rhythms of an animal organism arise from the ability to move, while the rhythms of natural growth spring from the power to expand. This difference affected the direction, force and equilibrium of the movements. Although the drawing of the human nude must obey the laws of gravity, the movements along the contours of the body may flow in either direction according to the pose; in a bamboo the movement of growth must begin at the roots and expand to the farthest leaf, so that the painter must feel himself into that one-way movement. In one, the display of force depends upon animal posture; in the other, the violence of the wind and storm may tear it apart. These two contrasts in direction and force set up quite contrary problems of equilibrium. In the nude, equilibrium is maintained by the physical coherence of the integrated organism and by the counteraction of volumes, so superbly realized in the contrappostos of Michelangelo. In the bamboo, equilibrium must be established between scattered and isolated stalks and leaves, so that the tensions are intimately connected with the voids.

How will the Chinese approach the problem of rhythm in the lesser forms of being—animals, fish, birds, and insects? They are functioning creatures just as men are, and rhythmically they are analogous unities of different parts and not built up on a basic rhythm as in the case of a tree or a rock. The answer is obvious if our thinking has become sufficiently Chinese. We normally experience them in motion and therefore the "idea of them" will express itself in swift lines of lateral movement. Lin Liang will extend the wings of a bird to increase the sense of alighting on a sandy shore, monkeys will swing in sinuous leaps from branch to branch, or fish will swim along a stream in interlacing lines. If the creature is in repose, the Chinese will emphasize not its bodily organism but some other essence of the idea, either the furriness of the animal, the featheriness of the bird, or the scaliness of the fish. Furthermore, the qualities of plastic organism were avoided in their favorite theme of the dragon, who seemed to epitomize their delight in abstract and fluid rhythm. Indeed, this characteristic rhythm might be called the mother of all Chinese rhythms, a kind of yin-yang dualism of reverse curves, concave and convex, stretched out to attain the utmost in speed. It is the rhythm behind all the freest rhythms in nature, rhythms of flame, of swirling water, and of flying clouds. It is the rhythm of growth, each branch being made up of responding curves, and it is the rhythm of erosion, present in most of the mountain wrinkles. One might ask if it is not also the rhythm of the muscles moving around the bones of the human body. That is true, but the test of rhythm is quality, not general shape; the curves of the body imply guided plasticity and power, while the curves of nature suggest the flux of natural forces. Awareness of this is

[42]

expressed in the various terms used to identify shêng-tung: in portraiture they speak of the "transmission of spirit" (chu'an-shên) with no mention of bodily movement; in animal, bird *7* and flower painting they seek "writing life" (hsieh-shêng), emphasizing the aliveness of these *36* lesser forms; and in landscape painting they express the evanescence of scenery in the poetical phrase of "leaving a shadow" (liu-yin). In each they insist on the special manifestation of *30* the spirit.

The stylization of rhythm presents equally striking contrasts in the east and the west. To our eyes all Chinese rhythm seems more stylized and decorative than ours, and this has been explained by Chinese writers as the influence of calligraphy on painting. Throughout their development the two arts have been twins and no one can really understand Chinese painting until he has practiced calligraphy and has known the feel of the Chinese brush when it moves like liquid fire and has experienced the fascination of Chinese ink when it creates a *44* living realm of values. However, to imply that stylization in China stemmed solely from calligraphy and that the influence of that stylization has been wholly beneficial is flatly contradicted by the facts. Historically, Chinese stylization had its roots in ideational mentality, and much of the abstract quality of later Chinese style resulted from the traditional re-working of the earlier abstract rhythms. In other cultures the archaic rhythms sloughed off before the revolutions of idealistic and naturalistic observation, but in China the ideational rhythms assumed a quality of movement, quite unique among the cultures, and capable of influencing the later periods. Compare the more static Gandharan handling of Hellenistic forms with the flaming creations of Lung Men which have caught the indigenous rhythms of the age of Ku K'ai-chih. The ancestors of these rhythms flourished in the amazing fluidities of the Han lacquers and had their origins in the zoomorphic rhythms of the bronzes; the progeny of these ideational rhythms survived through Li Kung-lin down to the ladies of Ch'ing with their swaying grace and elegance. When themes from nature superseded figure painting in Sung times, the search for the essence of the idea continued to keep the rhythms more abstract than in our own Renaissance—a tendency magnified perhaps by man's psychological habit of attaching a more decorative value to the rhythms of nature than to those of the human body. In contrast to the survival of this ideational stylization, the direct influence of calligraphy on painting began with the rise of "brush and ink" monochrome but did not become consciously assertive until the Yüan painters popularized "idea writing" (hsieh i) and thus prepared the way for *25* the calligraphic mannerisms of the Ch'ing "literary man's" style. An abstract art like calligraphy must inevitably injure a representational art like painting. The life movement of a bamboo will dry up when the stalks and leaves begin to be consciously fashioned to suggest ideographs, and in figure painting the folds of drapery will degenerate into ornamental mannerisms if the "nail heads" and "rat-tails" of the strokes claim our attention. In China calligraphic effects became the death of painting just as visual illusion destroyed design values in Europe. Our painting became too representational and their painting became too abstract. We must never forget that the goal of painting should be the vitality of spirit which can be lost by too much actuality or too much stylization. From this, we realize that shêng-tung and shih are intimately

[43]

related fruits of ch'i, and generally a work of art which has ch'i will have both the substance of spirit and life movement. Shih resided in the total visual effect and might be suggested by *40* posture, form, texture or other representational aspects; shêng-tung concerned rhythm alone. The relation between them may best be brought into focus by comparing the pitfalls of each. While the special dangers to shih were too much naturalism, idealism or expressionism, the special enemies of life movement were decorative stylization and virtuosity. Now it happens *27* that in the west we have prized Chinese painting, first, for its virtuosity, freely admitting that few of our painters begin to approach the Chinese in technical dexterity; secondly, for its *45* decorative qualities, admiring the stylization of brush strokes; and at the same time for its life movement which has often been called the supreme characteristic of Chinese painting. How can these three, virtuosity, decorative effect, and life movement, be bedfellows? The answer lies in the nature of rhythm itself. We have tended to emphasize natural rhythms in our forms and decorative order in our designs; the Chinese have blended the movement and measure of *23* rhythm in both their forms and their designs. As we shall see under the discussion of design, they have avoided the geometricized compositions of the west in favor of more dynamic movement, and in their forms they have often fused the living power of nature with the decorative quality of a single brush stroke.

PI OR BRUSH AND ITS STRENGTH

IN addition to the living qualities which depended on shih and shêng-tung, another kind of life resided in the technical means of brush and ink. Herein lay the real indebtedness of painting to calligraphy. According to Kuo Hsi, "the difficulty of handling the brush and the ink is the same as in calligraphy, which is of the same order as painting." Technically the two arts employed identical methods and sought similar virtues in the use of "brush and ink." In the handling of these, the Chinese painters have never been equalled, since they were trained from childhood in writing ideographs, and since a written character involves the two fundamentals of painting: rhythm and relationship. A Chinese ideograph is a pictorial abstraction, and a pictorial motif is a kind of ideograph. Consequently, the Chinese found meaning in brush and ink far beyond their use as technical means. "Nobody can understand the Tao of brush and ink unless he himself possesses the Tao"; that is, to the Chinese brush and ink are veritable fruits of ch'i. This is very difficult for us to grasp since we are so accustomed to think of them as techniques for representation. For the west the meaning is apt to reside in the qualities of form, space and light rather than in the touch of the brush or the value of the ink, each in its own right. In fact the individual brush stroke was lost in most of our paintings until modern times, and even in our drawings, which more closely approximate Chinese painting, the brush strokes were supported by modelling devices of shading and hatching, or by broken silhouettes to fuse the form with space, since the drawings were usually preparatory sketches for paintings. In a Rembrandt drawing, which has the greatest appeal to the Chinese eye, the brush and ink are marvelous but their purpose was primarily to create plastic form in light rather than to exist for their qualities of touch and tone. To the Chinese, brush and ink, being fruits of ch'i, were

ends as well as means. This does not imply that the Chinese minimized the realization of ch'i through representational values. "Brush outlined shape and in shape spirit dwells," or, in the words of Tung Ch'i-chang, "brush must be supplemented with wrinkles in landscape 24 painting, otherwise it is not brush"; and in figure painting the feeling for the bony structure under the flesh depended upon brush contours. Indeed, representationally, the Chinese painter had to say much more with a single brush stroke than any European ever attempted. Although brush shape was the backbone of his art, he went a step farther and asked: What is the quality in brush which directly and abstractly reveals the ch'i spirit? The answer was strength or li, which is certainly the most difficult of the fruits of ch'i for the western eye to estimate. In the eleventh century Liu Tao-ch'un deliberately linked strength (li) with ch'i, when he made his first essential "ch'i yün combined with li" instead of following Hsieh Ho's association of life movement (shêng tung) with spirit resonance (ch'i-yün). The aliveness desired was not only that which arose from representing the growing rhythms of nature, but this living quality should be the ch'i in the tip of the brush. The aliveness in the rhythm was not merely through shape but through touch, and the brush was an extension of the hand which 18 was the servant of the spirit. The great Wu "concentrated his spirit and harmonized it with the working of nature, rendering the things through the power of his brush." This was variously explained in different periods. Some writers likened it to the revelation of character in handwriting; "The signatures preserve the nobility and meanness, the adversities and successes; how could calligraphy and painting fail to reflect the high or the low ch'i yün?" Since touch deals with technique, most writers focused on the problem of strength (li) and the virtues by which it might be reached, especially maturity and uniformity. Although elderly handwriting has more character than youthful scrawls, the virtue of maturity referred rather to a pictorial maturity which came from years of practice and experience with every kind of brush situation, while uniformity demanded steadiness of wrist and arm movement. The brush being only an instrument, nothing must impede the smooth flow of the spirit through it. The traditional three faults, namely, to be stiff (pan), carved (k'o), and knotted (chieh), all referred to absolute freedom in the use of the brush. "Stiffness depends on a weak wrist and a too dense brush which does not give and take freely; the shapes of the objects become flat and thin; the strokes have no rounding sweep. Carving is caused by hesitation in the turning of the brush; the heart and the hand do not correspond, and the outlines of the pictures are drawn in sharp angles. Knottedness results if the brush does not move when one wants it to move and does not spread, when it should do so; the work becomes like a thing congealed and obstructed, which cannot flow freely." The effortlessness of the spirit needs the effortlessness of brush. However, danger lay in the pursuit of strength and effortlessness. One "should not take cursiveness and carelessness as maturity," nor should coarseness and violence be confused with strength even though the student is advised to be bold with his brush and to seem to penetrate the paper with his power. The spirit of landscape is tranquillity; therefore, how can a careless or impetuous brush capture it? And yet there must be strength in the brush which depicts the quiet trees and mountains. Once again, when confronted by the mystery of art and

the need for comprehending that mystery, the Chinese turned to the Taoist tensions between opposites. How shall we explain the new strength imparted to a single brush stroke, either a bamboo leaf or the character for the number one, by starting the stroke first in the opposite direction and then turning back on itself to increase the sense of vitality? The mystery within dualism was used by Liu Tao-ch'un in defining his six qualities: "to be coarse and vulgar yet *30, 28* to strive for brushwork; to be delicate and skillful, yet to strive for strength."

MO OR INK AND ITS QUALITIES

THE relation between brush and ink was perfectly expressed by Shên Hao:

> "Ink uses brush as its sinew and bone,
> Brush uses ink as its spirit flower (ching ying)."

Brush comes first and ink supported it. The great Wu "had brush but no ink" since in T'ang times plastic form was the ideal as in every classic age. The potentialities of ink were not grasped until form was adjusted to space, light and distance, first in the hands of the Sung landscapists and the devotees of ink bamboo and later when the Ming and Ch'ing painters *44* prized ink for its ability to express the more sensuous qualities of actuality.

Representationally ink was used to model form in light and dark, to place form in distance— "the further away the lighter the ink, is a principle which holds good," to suggest the obliteration of form in cloud, mist, fog or rain by graded washes, and to describe the play of light on forms by the use of variegated values. Ink even became a substitute for color because the *26* scholarly painters considered color a lower type of experience; "If you have ink, you have the five colors." This may seem to us an extreme example of suggestion but the practice led to one of the glories of Chinese painting—ink values of incredible nuances, used to depict that *22* which "both is and is not." "The color of mist is usually achieved by leaving the natural color of the silk untouched; if, however, an artist wishes to make the mist stand out, he may use a light, saturated ink, but neither ink nor brush strokes should ever be visible." Texture was added by Wang Yüan-ch'i to the accomplishments of ink when he said that "in landscape, ink should be hairy (mao)." But here the representational effect became secondary to the qualities of ink itself; "hairy is characterized by having its ch'i spirit ancient and its flavor liberal," just the opposite of landscape which is "naked." As in the case of brush, it is impossible to separate the abstract from the representational interest, although by its very nature ink with its qualities *10* is more intimately tied up with representation. In brush the shape defines both the form and the *21* touch, while in ink the degree of dark or light, thick or thin, wet or dry, dense or sparse, deep or shallow, vaporous or flat, directly determines the kind of plasticity, light and atmosphere. However, as might be expected, the Chinese were more concerned about the virtues inherent in ink itself, corresponding to the strength of brush. Of these the supreme virtue was the quality of being liquid (yün). As Shên summed it up: "How full of life-movement is the ch'i-yün, how strong is the brush, how fermented is the liquid quality (yün) of the ink?" Like all qualities of the spirit, yün eludes exact definition. It has the moral virtues of jade—

[46]

purity, freshness and distinction; "Whether the ink is thick or thin, dry or moist, it must not have the taste of worldly things (cooked food)." Perhaps the yün quality is best revealed by the phrase, "the brush sings and the ink dances." In compounds, yün was linked with wet, moist and misty. Closely connected with yün were two other qualities, ts'ai (value) and ch'ing (pure), as in Ch'ing dynasty. Literally, ts'ai refers to the glory of light around a halo and in compounds seems to mean light values. Ching Hao said; "Ink tones should be high and low, thick and thin according to the depth and shallowness of things; then the pattern of color (wen ts'ai) would be natural (tzǔ-jan) as if not made by the brush." When the Chinese attempt to explain these qualities of ink they contrast them with their opposites of glossiness and brilliant clearness, or they resort to poetical descriptions, such as saying that the ink of mountain shadows has the appearance of rain clouds rising, or they return to the tensions of Taoist dualism. "The ink must not be too heavy, else it would be muddy instead of pure (ch'ing); the ink must not be too light, else it would be dry instead of liquid (yün)." Likewise in the creative effort of capturing ink which is alive, the painter must preserve the equilibrium of effortlessness. "If the ink is too dry, it has no ch'i-yün, and if one absolutely strives for ch'i-yün, the result will be an excessive diffuseness; if the ink is too moist, beauty and reason will be lost, but if one absolutely strives for those qualities, the result will be a carved painting." If the painter is in tune with the Tao he will know that brush and ink are not merely technical means but that they are powers with cosmic import. T'ang Tai wrote: "Brush is activist and therefore captures the yang; ink is quiescent and therefore captures the yin. When the ancients painted they created the yang through the movement (tung) of the brush; they created the yin through the quiet (ching) of the ink. They created the yang by capturing the ch'i (spirit) with the brush; they created the yin by producing ts'ai (value) with the ink. [19] They used brush and ink to realize yin and yang."

IF we have grasped the spirit of ch'i and its fruits in the abstraction from nature of a single motif, we will realize that the same approach must determine the whole design. Abstraction and design, rhythm and relationship of parts cannot be separated; since every brush stroke is a part of the design, the spirit which creates the part will motivate the whole. Consequently, in attacking the problems of design we will expect the Chinese not to depend on representa-
17 tional values nor on geometricized composition for their unity but on some more dynamic fusion of the two, analogous to the wedding of life movement and stylization in the rhythm of each part. The most illuminating analysis of this creative process may be found in Shên Tsung-ch'ien, a writer of the eighteenth century. On the basis of the eternal flux of nature he described creation as k'ai-ho,—an "open-join" or "chaos-union" process. "From the revolution of the world to our own breathing there is nothing that is not k'ai-ho. If one can understand this, then we can discuss how to bring the painting to a conclusion. If you analyze a large k'ai-ho, within it there is more k'ai-ho. Even down to one tree and one rock, there is nothing that does not have both expanding and winding up. Where things grow and expand that is k'ai, where things are gathered up, that is ho. When you expand (k'ai) you should think of gathering up (ho) and then there will be structure; when you gather up (ho) you should think of expanding (k'ai) and then you will have inexpressible effortlessness and an air of inexhaustible spirit. In using brush and in laying out the composition, there is not one moment when you can depart from k'ai-ho." What a subtle conception of creativity! The same force which abstracted the smallest motif completes the design. In composing, the artist does not lean more heavily on rational principles than he did in his transformations of nature. Ch'i, the basic principle of rhythmic abstraction, has become k'ai-ho, the basic principle of rhythmic relationship. That is why east and west seem to have travelled such different roads toward unity; and what a satisfying approach to unity is this unity of coherence! Its implications may be sensed in the writing of an ideograph, in which we escape the distraction of representational likeness and deal directly with pure relationship. Each brush stroke is a force sending off energy in different directions, and as each stroke is added, a new tension is set up until the completed ideograph becomes an equilibrium of interacting forces. Observe also that in such
23 a creation two factors establish the equilibrium, the intervals between the strokes and the shapes of the voids between them, described by the Yüan authors as "spanning space" (chien chia). Also as each stroke is added in an ideograph, a movement is started which runs through the whole design. Every good ideograph depends primarily for its unity on movement and tension; both concern force and are intimately related, but movement is force which begins and flows in a direction, while tension results from the interaction of forces. They mutually need one another lest movement should become all flux and lest tension should degenerate into static balance. From this analogy of the ideograph we can understand why, in painting, when you expand (k'ai) you must think of the gathering up (ho), "or else the composition will

fly apart through the explosive tendency of creativity, and the structural unity of the whole will be lost"; when you pull the parts together (ho) you should think of the vital force which gave them birth (k'ai), "or else the result will be a dead mechanical adjustment and the whole will have missed the life breath of the spirit."

To realize such a dynamic conception of unity the Chinese resorted to many devices of which the two most effective were the synthesis of opposites (yin-yang) and the likeness of parts which may best be described by the term consonance. The relationship of yin and yang was the most basic single principle in Chinese design. Since k'ai-ho was simply a mighty yin-yang, it was inevitable that this dualism should have been applied to everything from the associations of thematic material down to the qualities of brush stroke. In calligraphy "the upper part should receive the lower and the lower should receive the upper, so that each part will have the appearance of being in response and not of turning away." This is coherence through the interdependence of opposites. Although this principle played a role in Chinese painting corresponding to the Greek principle of unity and variety, the two principles differed fundamentally. Unity is order derived from the chaotic variety of nature, whereas yin and yang are opposing forces which need one another for completeness. According to the Chinese, the substantiation of such coherence was to be found in the dualism of forces throughout the universe, whose interaction is the source of life—heaven and earth, male and female, birth and death. By analogy, every possible dualism was supposed to express this cosmic relation. Land-
15 scape painting was called a "mountain-water picture," implying the opposition of two basic elements. As one modern writer expressed it, "The art of painting consists of four characters, vertical and horizontal, combining and scattering (tsung hung, chü san) and this is what is meant by yin-yang constituting the Tao."

In design, things may be looked at frontally (chêng) or from the side (p'ien). This yin-yang
16 contrast may be observed in the whole layout. "The sovereign mountain is like a ruler of men, sitting upright at his court, the rest of the mountains are like the three dukes and the nine ministers, and still lower in the picture, the trees, rocks, and houses are like the hundred
30 officials." "The oblique lay-out is like the leaning waist of a dancing girl, the immortals whisking among the trees, a flying kite swooping down on the water, or the frightened beast galloping over the plain, sometimes as urgent as wind or rain, or as changing as the clouds." These two descriptions recall the majesty of Sung designs and the more flowing manner of the later paintings. According to Shên, "if one can only do chêng and cannot p'ien, one easily errs in stagnation," but "if you can only be p'ien and not chêng, then you easily fall into slipperiness." The same yin-yang was applied to upright and oblique brush strokes and these in turn might be used to relieve the layout itself. Wang Yüan-ch'i was considered marvellous because he was able "to use the p'ien brush to carry out his chêng situation," and Shên Chou was wonderful because he could "carry out a p'ien layout through a chêng brush." "This is what is known as: in chêng one does not neglect p'ien and in p'ien one does not miss the chêng." This contrast has been more fully considered to illustrate how the Chinese mind played with every possible dualism and sometimes departed from strict consistency.
26 Qualities also were constantly opposed: "The sparse and dense should be interspersed," "the light and the thick should balance," and the "concave should counteract the convex." In

pictorial rendering, "thick ink should be relieved by thin," and in the simplest two-part design such as a painting of flying geese, if one flies downward, the other should fly upward. That these oppositions were never statically conceived is forcefully revealed by the phrase "the empty and the solid should give birth to one another." In addition to this straight dualism *22* of opposites, the Chinese extended the principle of yin-yang to include the relationship of mutual need between objects of the same kind. "The host mountain needs the guest mountains," the exalted tree requires the humble, and "the peaks seem to greet the hills." Sometimes this need expressed itself in a sharp contrast, as in the Ming comment that a painter "must always include some dead trees even in the most luxuriant foliage." To the western mind this sounds suspiciously like a note of variety, and undoubtedly the Chinese artist appreciated this effect of contrast, but this advice was chiefly directed toward bringing out the living quality of the luxuriant trees by the yin-yang opposition of a dead tree rather than merely toward breaking up the monotony of all green trees. The Chinese constantly recognized the claims of variety but their attention was focused on a more profound relationship, as in the remark, "a dangerous cliff, standing sheer, depends on distant hills as a screen," where they felt a mutual dependence between the two in which the sheerness of a nearby vertical demanded the complement of a far-off horizontal. Similarly, "when the host mountain is frontal, the guest mountains should be low, and when the host mountain is oblique, the guest mountains should be far." In one, the situation of height required scale, and in the other, the situation of depth requested distance. From such subtleties of relationship it was only a step to the use of the paradoxes of Taoism in trying to describe the mysterious dualism of yin-yang in artistic creation. The doctrine of non-action may be sensed in many pictorial remarks, such as: "How trees seem to struggle and to yield to one another," or "If you wish a mountain shape to turn, go against its tendency and *24* then turn." In an extreme form it becomes: "When in your eyes you have mountains, only then can you make trees; when in your mind there is water, only then can you make mountains." Occasionally these remarks suggest the Chinese notion of illusion which developed out of Taoism:

> "Beyond mountains there are more mountains; *19*
> Although they appear to be disconnected, they are actually not,
> Beyond trees there are more trees;
> Although they appear to be joined together, they are actually not."

The types of yin-yang to be found in Chinese painting are many and various, and will often escape the most careful scrutiny of the western eye and the analytical appraisal of the western mind. Fundamentally the principle of yin-yang stems from Taoism and means the relationship of opposing forces which are mutually necessary to one another.

THE UNITY OF CONSONANCE

ANOTHER principle of relatedness, consonance, depended upon the likeness of parts rather than upon their opposition. The Chinese critics rarely discussed this means of getting unity, probably because it had been inherited from early times and had become an accepted traditional practice in contrast to yin-yang which was developed by the Sung and later thinkers. Once again we must constantly keep in mind that most Chinese principles have their roots in the remote past, and that the early attempts to get unity became refined and re-interpreted in later periods which had become aesthetically articulate. By its very nature, the ideational approach of Pre-T'ang painting made it difficult to achieve any kind of coherence. In that *1* period the visualization isolated each part, the isonomic presentation resulted in an additive design in which the motifs were dispersed over the whole field, and absence of setting deprived the composition of any enveloping unity of space. In fact the schemes of compositional control *2* were largely fortuitous, depending upon some important iconographic feature, on the shape *3* of the format, or on such conventions as the "register system" of superimposed rows of figures. In all early design, consonance was the chief method for holding the isolated and scattered parts together, either by repeating identical motifs or by using similar rhythms in diversified objects. Both of these methods became outstanding characteristics of later Chinese painters. In the wandering landscapes, with their widely separated solids and voids, the repeat of a *15* rock and tree theme throughout the composition will impart a sense of consonance to the *44* whole. In paintings of birds and flowers, the selection of similar rhythms or textures or colors will blend the most intractable shapes and will pull widely separated motifs together. In the *23* use of brush and ink, a certain type of brush stroke may run through the whole design, or the *18* aspect of the scenery may have a unified mood by the use of a distinctive tonal wash. Throughout Chinese design the principle of consonance has assumed the most subtle manifestations and has played a major role, while in European painting it has been held in less repute, perhaps because we have associated it with the patternistic effects of rugs, textiles, wallpapers, and the so-called decorative arts. While we have valued consonance primarily for its decorative effect, the Chinese have sought in it a deeper significance. A typical Southern Sung landscape *22* by Ma Yüan or Hsia Kuei, with its rain and windswept terrain, will be permeated with the principle of consonance, so that mountains, rocks, trees, boats, houses and leaf-pointing are blended through rhythmic likeness; yet we would never apply the word decorative to such a design. On the other hand, many Ch'ing landscapes are so ornamental that they might be *28* appropriate on a piece of porcelain.

What, then, is the relationship between consonance and decoration? A decorative effect arises from a departure from the natural, especially the extreme stylization of natural rhythm, the use of non-naturalistic color or texture, two-dimensionality, and patternistic repeats. None of these are requisites of consonance since the repeat of motif must be regular in decorative art and the repeats of consonance may follow the most subtly varied spacing of a Sung landscape; that is, the decorative value of consonance as a principle of design may be very negligible.

[52]

When Europeans first saw Far Eastern art and derided it as decorative, they were referring to its use of stylization, flat planes, and decorative color and not to the presence of consonance. In fact, many of the finest examples of consonance, such as the Southern Sung designs, would escape our notice simply because the western eye would be looking for the patternistic repeats which would enhance the decorative effect of the design, so strikingly illustrated by some of the most famous Baroque or Rococo ceilings. The potentialities of consonance of design values as contrasted to decorative effect have just begun to be explored by our modern painters. In China, as early as the Sung period, the principle of consonance was given a profound meaning by being linked up with the philosophical speculation as to the oneness of the Tao which permeated the universe: "Looking at the things made by heaven and earth, one may find that *15* one spirit causes all the transformations, and this moving power influences in a mysterious way all objects and gives them their fitness." How will the artist attempt to paint this all-pervading oneness? In face of the infinite variety of nature, he will try to select mountain stratifications, branch rhythms, cloud contours, and swirling cascades which have related rhythms. This is the unity, not of order but of consonance.

CHANG-FA OR COMPOSITION

Just as the general principles of unity, variety, balance and movement have controlled much of our thinking about design, the general principles of k'ai-ho, yin-yang, consonance and equilibrium of tensions have determined the Chinese approach to problems of grouping, scale, sequence, emphasis, and the scheme of the whole composition. In each case the goal has been unity, but the cultural orientations have emphasized different methods for attaining that pictorial unity. Our scientific bent has made us lean heavily on the objective appearance of things for cohesion and on geometrical organization for order, while their reflective tendency has turned them toward the intellectual relativity of things, and mutual need and likeness of parts to give a sense of oneness. This fundamental difference in orientation has been restated here because compositional devices varied according to period. Pre-T'ang methods have their closest analogies in our own Middle Ages, and the Ch'ing masters often tried to achieve the more continuous spatial unity which began in our Baroque period. However, we only need to juxtapose Ku K'ai-chih and Giotto, or Wang Hui and Constable to realize that behind all the variations due to historical periods there lie cultural orientations which guided the approaches to problems of design.

The most elementary problem of design is how to combine a few parts in a group. Since the Chinese were interested in the ideas of things rather than in their outward appearance, they created groups of objects which would be immediately intelligible instead of visually convincing. The number of parts in a single group must be readily grasped even though our actual experience of nature is one of prolific multiplicity, whether of crowded streets, herds of animals, flocks of birds or wooded hills. To westerners, so devoted to a multiplicity of things, most Chinese arrangements seem rather thin. The urge to reduce content to its essentials has resulted in designs of the fewest possible elements, generally not more than five figures, which might be amply demonstrated by a comparison between the scenes from the life of Christ and those from the life of Confucius. If the iconography demanded more than five figures, the composition usually broke up into small groups of five or less. The exceptions to this generalization occurred when the more numerous groups were held together by some object such as a table or the emperor's horse surrounded by his entourage, and in these cases the mind accepts the whole group as a single unit instead of as a numerical relationship. Precisely this distinction was applied to the grouping of trees in the application of the "law of five." It was said that "if you knew five trees, you could render a thousand." Consequently in the foreground, where the trees counted as a numerical effect, their grouping usually obeyed the "law of five," but in the middle distance, where they represented dense woods or forests, the trees were multiplied into an extensive group which acted as a single unit of continuity instead of a numerical composition. The trees became a grove and not a group. Even in the later periods, when these forests were brought down from middle distance into the foreground to increase the naturalistic effect, the important trees of the design were still subject to the "law of five." This raises one of the most intriguing aspects of Chinese art, the psychological

integrity of their intuition. Even though they abandoned the truths of representation, such as plasticity, cast shadows and continuous space, nevertheless, in their free creations they followed certain psychological truths which enhanced their design values. Centuries ago they intuitively sensed that the average person cannot grasp more than five as a numerical group, a fact we have only recently demonstrated in our psychological laboratories. Whenever the theme lent itself to this principle, the "law of five" was invariably preferred, as in the favorite theme of a whole painting devoted to a single group of trees. However, this principle was not permitted to become a dogma; if the situation or the nature of the idea demanded a contrary principle, the quest for ch'i and k'ai-ho always came first. The very essence of our experience of reeds and grasses is multiplicity and therefore the Chinese massed them together; *44* sometimes the stalks actually followed the five rule although their numerical sparsity was concealed by the density of leaves to give the effect of profuse growth. Many flowers, such as chrysanthemums, grow naturally in clusters, but they were generally broken up into smaller groups, again often subtly obliterated by leaves or some other device. The real surprise is that in all these situations the Chinese almost universally go against the natural grouping in favor of a more intelligible design. Despite the clustering of bamboos, the most treasured paintings of bamboo consist of only a few stalks; despite the rich possibilities in flocks of birds and herds of animals, the great paintings contain only two or three. Because of yin-yang dualism the Chinese seemed to prefer the contrast of two and, next to that, a group of three; four-part compositions were rarely used and five-part compositions were often split into groups of two and three. This limitation of design to a principle of the fewest possible elements was a constant characteristic in spite of the demands of natural appearance, iconographic situations or period naturalism. Its value to content and design should be underlined. In content it compelled the artist to say much with little and to concentrate his meaning into a few forms; in design it resulted in simplicity and clarity so that the average Chinese painting seems even more readable than a European drawing. This gave to Chinese painting a rare directness and potency. Sometimes what the artist has to say may seem trivial, but it is almost always said *12* with distinction. Nor should we neglect the decorative potentialities of numerical simplicity since most satisfying decoration is based on motifs which are instantly acceptable and require little analysis on the part of the spectator. In painting, the decorative clarity of twos, threes, and fives may sometimes become too obvious but generally speaking they reinforce the intelligibility of both content and design. An analogous passion for simplicity determined the kinds of parts to be used in a single group; variety is the law of nature but not of Chinese design. We have already seen how variety in subject matter was strictly conditioned by the choice of only the essentials and by natural associations; to this we must now add the restricted use of variety in formal relationships. The heterogeneous types of a Daumier cannot be found in Chinese painting; instead, a philosopher or two with their servants were repeated again and again, and the most elaborate figure compositions maintained a certain uniformity of scholarly *11* types. In the landscape of the T'ang and Sung periods the normal practice was to employ not more than two kinds of object in any group, and in a group of five trees, two species *15*

[55]

would be used which resulted in both a suggestion of yin-yang and a readily grasped theme. To unify the whole design, landscape scrolls often employed only three species of tree and one kind of rock. Animal and bird groups were usually restricted to one species, and if variety were desired, a second group of another species would be given a secondary role. More than three varieties of flowers were seldom combined, even in the very elaborate Ming pieces, but a motley effect was created by adding trees, animals, and birds to the ensemble. Only in the painting of fruits, insects and water creatures did the Chinese indulge in wide diversity, but restricted the objects to a single class.

The Chinese approach to difference of size in a group will seem quite arbitrary to our minds. We have been so bound to representational accuracy that we are repelled by any departure from natural size unless it has some iconographic justification. However, in all ideational art, objects are given size according to their importance, the king being twice as large as his subjects, or a tree half the size of a man when it merely informs us that the scene is out-of-doors. Something of this principle of size according to significance persisted in the Chinese tradition. The favorite disciple of Confucius looked like a little boy beside him and the most important figure in any group was usually the largest. In landscape the host-guest principle emphasized the dominant mountain or tree. At first glance this arbitrary handling of size would seem to have given the Chinese an advantage over our painters, but we achieved more varied relationships by the use of perspective with its infinite number of sizes through dimunition. Since each Chinese group was confined to a narrow plane of depth, depth contrasts were secondary. Even in Ch'ing times, when trees of a single group might be placed in depth on both sides of a road or gully, the farther trees were not necessarily the smaller and might be the larger if their size improved the design. If the Chinese ever became interested in a purely visual problem, it invariably belonged to the kind of psychological illusion which intrigued Cézanne. For example, in discussing size: "If it is open-worked (t'ou), although the form is short yet it appears to be long, if it is oblique (lo), although the form is thick, yet it appears to be thin." Or again: "The clouds on the mountains should be thick! I tried to understand this for thirty years but could not grasp it; then my old teacher said to me, 'Make the mountains thick, and then the clouds will be thick.'" In all of these relationships of number, kind, or size, representational values bowed to design values.

Thus far, we have considered the advantages of simplicity and clarity, but they are accompanied by the dangers of thinness and hardness. These dangers were increased by the lack of any encompassing spatial setting or continuity. Occasionally, in one of our sketches in which the background has been omitted and only the salient figures have been outlined, we suddenly realize how much western paintings depend for cohesion upon their enclosing spatial setting. If elements are spotted against a void of silk or paper, they necessarily look very isolated and scattered, especially if grouped in twos and threes. How will the Chinese avoid the impression of sparseness and how will they compensate for the lack of cohesion created by an imitation of the continuity of physical actuality? They relied upon subtlety of spacing, since spacing is the key to Chinese design. According to Tung Ch'i-ch'ang: "Whenever one

[56]

paints landscapes, one must pay attention to proper dividing and combining; the spacing is the main principle. There is the spacing of the whole composition and the spacing of the parts of the picture. If one understands this, one has grasped more than half of the principles of painting." The rhythm of intervals played the same role in the relationship of motifs that 15 was performed by the rhythm of line in their abstraction. The arrangement of the parts was tied up with the manifestation of universal spirit,—"the position-pose (t'iao-li) is life breath (shêng ch'i) that can be observed." Consequently, from the relationship of the largest themes down to the dotting of moss on the ground, the spacing was crucial. In the painting of bamboo although the leaves may seem to be a confused mass of foliage, a closer study will reveal groupments of not more than five leaves in which each leaf is rhythmically adjusted to the other leaves, and in turn these groupments follow principles of rhythmic sequence. In order to understand these principles we will first examine the intervals of a single groupment of figures, trees, rocks, or the lesser forms of life, leaving for later the special problems of scale and space arising from the relation of group sequences in the more extensive designs.

The east and the west have approached the arrangement of parts from opposite poles; we have aimed at tying forms together and they have emphasized the intervals between them. Because of the more naturalistic orientation of our culture, the relationship of forms was largely controlled by the continuity of appearance. Since the world is made up of solid forms held to a ground plane by gravity and intermingled in spatial depth, we have prized the thrust and counterthrust of plastic forms both laterally and in depth, and have used all the devices of overlapping, foreshortening, and active poses and gestures to fuse the forms together. How magnificently this kind of organization has been realized in Rubens and the Baroque painters! But in how few of these western figure designs are we vividly aware of the intervals between the forms? The question simply does not arise because our attention has been focused on the forms and the connection between the forms. In a Chinese design we feel at first sight that the figures seem unconnected. Various devices were invented to give a maximum awareness of the intervals; isolation of the figures has been the standard practice, and, when over- 8 lapping did appear, it was restricted to the minor figures so that the important figure or figures might be left alone. Isolation meant that the forms must be related mentally rather than visually. Normally no ground plane established a physical connection between plastic forms held down securely by gravity, but rather incorporeal forms frequently seemed to be floating across a back- 5 ground of void. The implied ground plane of neutral silk or paper was so shallow that the figures in any single group practically existed in a lateral plane. How definite and how measurable this lateral placement made the intervals between the figures! It is easy to estimate lateral distance but difficult to judge depth distance, especially when the depth has not been established by the science of perspective. Furthermore, lateral placement in all directions was made possible by the Chinese convention of a high tilted background, so that the eye can move 6 freely up and down as well as right and left among the figures of the group. We now recognize that this effect of planes and the isolation of the figures stemmed from early ideational thinking—these characteristics becoming completely transformed by the Sung thinkers so

that they might become vehicles for expressing the Tao. How can the universal spirit be revealed in the arrangement of parts? Everything we have said as to the life movement of motifs applies to the life movement of spacing—a wedding between the natural and the ordered. If the spacing copied the casual and accidental intervals of actuality, the spirit would not be caught; and if the spacing was too regular, the design would become mathematical and dead. In some early designs, especially in copies of T'ang works, the regular arrangements of the triangle, square and trapezoid were popular and may have been introduced from the west, but by Sung times the spacing reached a subtlety which has remained unequalled in the history of painting.

THE EQUILIBRIUM OF TENSIONS

Mu Ch'i can paint six persimmons upon a square foot of silk so that the tensions between them 39 seem to be inexhaustible. Not only is each circle of fruit perfectly adjusted to all the others by the equilibrium of the intervals, but the measure of those intervals is accentuated by the ideographic stems in black ink and strong brush which unmistakably mark the distances and the rising and falling movement within the group. Rightness of interval, furthermore, is bound up with the shapes of the motifs. What nuances arise from the full round curve of one persimmon and the flattened contour of another in relationship to the distance between them! If the round contour were flattened, the distance would become too great, while if the flattened contour were rounded, the persimmons would become crowded. The relation between contour rhythms and the movement and tension of intervals is the most baffling problem in design because it combines the rhythm of abstraction with the rhythm of relationship. Every contour does double duty—it defines the motif and it possesses design value. To achieve plastic form and foreshortening we have emphasized the modelling power of the contours at the expense of their design value; if we traced the bare outline of many of our figures, the resulting shape would often be scarcely intelligible because the contour is so broken by lines moving around the volume instead of along the silhouette. The Chinese neglected the modelling side of contour in favor of its design value. Although they had mastered foreshortening in T'ang times, they continued to avoid foreshortened poses and to make figures bend to the right and to the left; even true contrapposto was twisted and somewhat flattened to give lateral movement, 5 and, where forms were foreshortened, they were hidden by draperies in order to keep the movement in the picture plane. This cannot be ascribed to the shallowness of the implied depth in any group, since figures which act merely as connections between front and rear figures were still placed laterally, and the desired movement in depth had to be either implied or supplied by the diagonals of mats, tables, toilet boxes, musical instruments, or 4 some other mobilia. What did this signify? That the maximum awareness of intervals must be integrated with a maximum awareness of the contours marking the intervals. This explains the unique character of Chinese tension. In a figure design it became possible to suppress most of the poses and gestures which might emotionally and formally relate the figures, and still to create vibrations between self-contained figures, who seem to be thinking their own thoughts, purely by the spacing and the interaction of contour rhythms which vitalize the voids between the figures. Outward action was sacrificed in favor of inner tension. In the painting of dragons, flying birds, swimming fish or any theme requiring speed of movement, 34 the Chinese artist carefully avoided the descriptive effect of violent action and adjusted his linear rhythms to one another in order to heighten the sense of relatedness. In the case of inanimate objects, such as the persimmons, the artist tried to impart as much movement as possible to the contours in order to intensify the vibration between them. The Chinese never forgot the relativity of the Tao and each situation had to be handled as a unique interplay of forces. New problems were set by period as well as by subject matter. In the early grouping

15 of trees, when the artist freely created ideal arrangements, tension resided in the overlapping of the motifs, but in the more natural grouping of later times, when the trees stood virtually

30 separate from one another, tension was centered in the rhythmic variation of their heights enriched by an interplay of increasing intervals in depth. A contrast between the tension of trees and of rocks was made by Shên Tsung-ch'ien when he said the "t'iao li mo lo were the most important things in painting." T'iao meant "to unify those which are combined, and separate them, and not let them be ill-assorted and scattered"; and li meant "to restrain those which are confused, and arrange them, and not let them be tilted and oblique." T'iao li was applied to trees: "When you set forth trees as a forest, each tree has its own t'iao li; although

28 a hundred or a thousand trees, they also go together to form t'iao li." Mo lo was applied to rocks: Mo meant "to relate things together which are concealed and cannot be seen, and it is known as the chalk line," referring to the linking together of rock strata as pearls might

25 be held by an unseen string. Lo is that which relates things and is apparent and can be seen;

16 it is the so-called outline referring to the enclosing outline of the wrinkles like the big thread around a net. To apprehend such subtleties of tension requires years of study and even then it is not easy to define the peculiar distinctions of Chinese design. We can only point out its locus which is the interrelation between rhythmic contours and rhythmic spacing in the plane of the picture. How dismally we have failed to grasp this salient trait of Chinese design has been shown by our incredible confusion between this design by motifs and intervals, and the design by area of the Japanese woodblock prints. When we speak of the Oriental, more properly the Far Eastern, influence on western painting, we are referring to the patternistic decoration of Japan, taken over by Degas, Gauguin, and Matisse. When motifs and intervals are both reduced to areas of relatively equal value and these areas are then interlocked in a continuous pattern like a jig-saw puzzle, it should be obvious that the design must lose the Chinese kind of tension, which might be termed "ideographic tension" since it depends upon lines and the intervals between them. To cancel the static effect of area pattern, Matisse introduced the tension of colors and, through values, the tension of space, so that the very word tension calls Matisse to mind before any other artist except Cézanne, who specialized in tensions between the axes of his forms. These western types of tension are all more visually assertive than the ideographic tension of China; the colors of Matisse startle us by their violent contrasts and intense vibrations, and the revolving volumes of Cézanne create powerful opposing thrusts which shock us with their departure from natural equilibrium. Ideographic tension

23 speaks in innuendos and clever paradoxes. Visually, by the concentration of representation in the brush contours, by the isolation of the motifs, by lateral measurement of the intervals, the Chinese arrangement of parts is made patently readable; but intellectually the subtleties of relationship in terms of movement and tension remain as inexhaustible as the mysterious forces of the Tao which was their inspiration.

SEQUENCE AND MOVING FOCUS

CHINESE painting is an art of time as well as of space. This was implied in the arrangement of the group by movement from motif to motif through intervals; in the extended relationship of groups, movement in time became the most memorable characteristic of Chinese design. Historically all early paintings, whether Egyptian, Archaic Greek or Pre-T'ang Chinese, *1* lacked spatial unity and had to be experienced as a sequence of pictorial motifs, to be read by the spectator like so many pictographs. In such an ideational art the principles of design were conditioned by the isolation of motifs, the movement of the eye through intervals, and the tying together of each motif to its adjacent motifs. These early principles were later transformed and enriched until they reached their fulfillment in the supreme creation of Chinese genius—the landscape scroll. A scroll painting must be experienced in time like music *15* or literature. Our attention is carried along laterally from right to left, being restricted at any one moment to a short passage which can be conveniently perused. This situation entirely alters the choice of design principles. The design as a whole will, like music, have a beginning, development, and ending. Many scrolls parallel the musical sequence of exposition, development, and recapitulation, and others have a definite climax like a drama. Specific themes will be needed so that the spectator will be prepared by his memory for what is to come as the scroll unrolls, and will appreciate the various treatments of the themes and the introduction of new material. In order to describe such an experience in time we instinctively avoid the terms for spatial design and resort to the terminology of music; we speak of themes and their expansion, contraction, and inversion, of melodic lines and their counterpoint, of the accelerandos and ritardandos of spacing, and even of crescendos and diminuendos as the landscapes become thick and profuse or fade away into the nothingness of mist. The right timing of these qualities depends on lateral movement rather than on movement in depth, and the lines of movement are not mere leading lines but linear melodies which are the very substance of the design. Although these principles of time are self-evident in the scroll, few western observers have realized that these same temporal principles were used in the hanging paintings *17* and the album pieces. No matter how few the motifs or how simple the design, we must see *22* it step by step if we are to apprehend all of its subtleties, because design in time did not arise from the shape of the format but from a unique attitude toward space. In the European tradition, the interest in measurable space destroyed the "continuous method" of temporal sequence used in the Middle Ages and led to the fifteenth century invention of the fixed space of scientific perspective. When the Chinese were faced with the same problem of spatial depth in the T'ang period, they re-worked the early principles of time and suggested a space through which one might wander and a space which implied more space beyond the picture frame. We restricted space to a single vista as though seen through an open door; they suggested the unlimited space of nature as though they had stepped through that open door and had known the sudden breath-taking experience of space extending in every direction and in- *17*

finitely into the sky. Again east and west look at nature through different glasses; one tries to explain and conquer nature through science, and the other wants to keep alive the eternal mystery which can only be suggested. Each seeks truth in its own way and each has its strengths and weaknesses. The science of perspective achieved the illusion of depth and gave continuity and measurability to the spatial unit; however, perspective put the experience of space into a strait jacket in which it was seen from a single fixed point of view and was limited to a bounded quantity of space. This control of space might give measure to an interior figure scene but it was certainly harmful to landscape painting.

The Chinese treatment of architectural settings will illustrate the most elementary contrasts between the eastern use of a moving focus and the Renaissance passion for perspective. Instead of a centralized focus the Chinese preferred architectural elements parallel to the picture plane, or with one side parallel and the other giving a strong movement of oblique lines in one direction (a kind of rhomboidal treatment), or, if the inscenation was placed diagonal to picture plane, the diverging lines were emphasized to lead the eye out of the picture. In all three instances the artist increased the lateral movement in time; this movement was then regulated by various devices such as screens and garden walls.

Furthermore, the two favorite types of inscenation in the west were neglected—the stage interiors and the town settings, both stemming from Hellenistic prototypes. Instead, the Chinese showed a section of the interior, or combined interiors with exteriors of terraces, gardens or landscape backgrounds. If the setting was a pure interior they often introduced screens with landscape vistas. In any case they tried to avoid the effect of a focused and enclosed setting and liked to play with planes in moving sequences, ranging from the T'ang use of a single screen against areas of void to the complicated shifting of planes in all directions in the Ch'ing designs. These architectural planes and their diverging lines were always more informative than descriptive and by means of them the Chinese achieved fascinating area relationships.

In the rendering of landscape the use of one-point perspective is even more damaging than in architectural inscenation because it violates our experience of nature; out-of-doors, our eyes are compelled to turn in every direction to encompass the scene. Reverse perspective, in which the lines converge in the eye of the spectator instead of in the vanishing point, would have been much truer to psychological fact. This type of perspective has often been falsely imputed to Chinese landscape painting, even though the Chinese could never have been satisfied with any method of scientific representation and always insisted upon artistic presentation. They practiced the principle of the moving focus, by which the eye could wander while the spectator also wandered in imagination through the landscape. By this device, one might travel through miles of landscape, might scale the mountain peaks or descend into the depths of the valleys, might follow streams to their course or move with the waterfall in its plunge. How wonderfully our apprehension of nature has been expanded, combining in one picture the delights of many places seen in their most

significant aspects. Such a design must be a memory picture which the artist created after months of living with nature and absorbing the principles of growth until the elements of landscape were "all in his heart." Then, and then only, could he freely dash off hundreds of miles of river landscape in a single scroll in which the design evolved in time like a musical *15* composition.

DESIGN IN DEPTH AND CH'I-FU

IF we grant that the Chinese approach to nature caught the experience of space in time more completely than scientific perspective could, we must admit that the visible tangibility of space was sacrificed. No memory could possibly retain what the eye of a Vermeer or Velásquez could see, and the representation of tangible space requires the close observation of atmosphere, light, cast shadows, and textures which defy the visual memory. A moving focus can only be achieved with mnemonic themes which can be interrelated with the utmost freedom, often counter to the requirements of actual space. How then will the Chinese compensate for the loss of tangible space? They will try to suggest all the qualities of space by abstracting the essentials. In the words of Cézanne, the whole trick of painting landscape is to make it go back. Depth is the first essential. To achieve depth, scientific perspective depended, first, upon a continuous receding ground plane which held all the verticals together, and, secondly, upon a diminution in the size of the verticals according to a vanishing point or points. Instead, the Chinese perfected the principle of the three depths, according to which spatial depth was marked by a foreground, middle distance, and far distance, each parallel to the picture plane, so that the eye leapt from one distance to the next through a void of space. Historically this method emerged in every culture out of man's first attempt to render depth. With only the flat planes of ideational imagery at their command and with no foreshortened ground plane or diagonal connectives, the early artists arranged their flat planes in echelon like the wings and backdrop of old-fashioned stage scenery and placed their planes arbitrarily at higher levels to indicate any increase in depth. This convention of three depths survived in many Renaissance backgrounds but was usually annulled by a foreshortened horizontal ground plane, as in Perugino's "Christ Giving the Keys to St. Peter," where the fact that the figures stand in lateral rows at three depths passes unnoticed before the railroading convergence of the piazza perspective. We of the west did everything to destroy the limitations of the three depths, while the Chinese, in their inimitable way, discovered such wonderful potentialities in the earlier convention that even when a continuous unbroken ground plane was known in Ming times, they still preferred to cling to the principle of the three depths.

What were these potentialities? For the spacing of distance this use of three depths gave the artist an arrangement of motifs and intervals as clear-cut and intelligible as the lateral spacing of elements. Representationally, however, leaps in depth through undefined voids created an impression of immeasurable space. To further heighten this sense of unknown vastness the Chinese used cloud, mist, light, and weather conditions to make the voids between the three depths more vague, thus suggesting the boundless infinity of the Tao and the breath of ch'i spirit throughout the landscape. Moreover, the absence of a single arbitrary horizon enabled the artist to freely adjust the three levels of solid terrain to give the impression of a panorama, thus increasing the range of the distance. This should never be confused with the western "bird's-eye view," in which the whole is continuously organized under scientific perspective with a fixed angle of vision. In the Chinese system, each of the three terrains was seen laterally

under a moving focus and in depth from whatever height which best brought out the character of the terrain. Far distance would always be imaged in silhouette; middle distance might be tilted up to describe an extensive panorama, or it might be seen almost *en face*, like the far distance, if the artist desired a dense foreground; and the foreground might be compressed *29* if it served primarily as a *repoussoir* for middle or far distance. These many possible arrangements set the larger framework for the design principle of ch'i-fu (rising-falling).

Closely connected with this principle of the three depths, the Chinese classified different kinds of distance according to their character. Kuo Hsi recognized three kinds of distance: kao yüan (high distance), in which from below you look up the mountains; shên yüan (deep *28* distance), in which from the front you look toward the rear of the mountains; and p'ing yüan *17* (flat distance), in which you look from a nearby mountainside across low flat hills. Since these *25* three distances have been mistranslated and misunderstood, let us note that the eighteenth century Shên Tsung-ch'ien supported this interpretation of the three yüan, when he referred to three kinds of mountain experience: from below, feeling the sheer verticality of the mountains; from the level, looking through the mountains; and from a high vantage point, gazing across an expanse of distance. To these three traditional types of distance Han Cho in the twelfth century added kuo yüan (broad distance), "when there is a near shore, expansive water, and vast distant mountains"; mi yüan (lost distance), when the mountains have mist and fog, and wilderness and water are separating and indistinguishable; and lastly, yü yüan (secluded distance), when the scene and its attributes have reached the ultimate and are vague and ineffable. In broad distance, Han Cho clearly anticipated the extensive ground planes which Ni Tsan indicated by stretches of water; and in lost distance and secluded distance, he recognized that the most elusive distance can be best suggested by the obliteration of forms, *22* which became the special forte of the Southern Sung masters in contrast to the T'ang and Northern Sung preference for solid forms. In all these various kinds and treatments of distance, we should underline the role played by mountains. The flat countryside of western painting, with distance measured by cloud shadows or atmospheric perspective, is absent from the Chinese repertoire, in which the mountains mark off the distances. Chinese painting is an art of verticals rather than of horizontals even when the desired effect is distance. Of course other devices were adapted to each special kind of distance: since the "aspect of kao yüan (high distance) is abrupt," waterfalls will magnify the scale and the sheerness of height; *16* since "the idea of shên yüan (deep distance) is reiteration," clouds which separate the moun- *19* tains will increase the depth; since "the idea of p'ing yüan (level distance) is blending to- *31* gether," low lying bands of mist will be appropriate to levelness. Similarly, "concerning men and objects in the three distances, in kao yüan they are clear and visible from afar (because they are closer), in shên yüan they are fine and small (because they have diminished through distance), and in p'ing yüan they are blended and indistinct" (because of the association of mist and levelness). That is, a kao yüan design in height would probably play up the foreground, a shên yüan design in depth would depend chiefly on middle distance, and a p'ing yüan design would emphasize the far distance.

THE use of the principle of three depths instead of scientific perspective also affected scale. The Chinese were never interested in natural physical scale, although they had a rule of thumb for size and although they observed the dimunition of size according to distance: "If a mountain at a distance of several scores of miles does not have the size of a tree, then it is not a large mountain; if several thousand trees at several scores of miles do not have the size of a man, then they are not large trees." Historically, natural scale was not developed until the Ming period, just as the practice of having one scale for the figures and another for the setting persisted in Europe until the seventeenth century. Fortunately the Chinese never faced the problem of scale in its most acute form—that of figures enclosed in an interior, where the figures would be dwarfed to insignificance if reduced to the scale of the architecture. Normally figures, if not in a void, were placed in a garden or landscape setting; and interiors, if used, were generally seen in part through a window or door. In the portrait of a tree, for example, where magnitude counted as an essential of the idea, the Ming masters would paint in physical scale. However natural scale always had to bow to pictorial scale. As we have already seen, the yin-yang quality of the host-guest relationship was the determinant, and, in the same way, size according to distance never followed the laws of geometric perspective but the needs of the design. Foreground features might be diminished to avoid obstruction and overemphasis, and far distant objects, which were too minute to count pictorially, might be enlarged to act as a counterpoint to the middle distance or foreground. Although the principle of the three depths allowed great latitude in the size as well as in arrangement of the parts, these departures from the natural seldom disturb our sense of scale because the Chinese constantly suggest more scale than they represent. "If one wishes to paint a high mountain, one should not paint every part, or it will not seem high; when mist and haze encircle its haunches, then it seems tall." "A stream painted in its entire course is not only without grace in its meandering, but it resembles a drawing of an earthworm." "When its course is interrupted and covered, then it seems long." The same applied to roads, waterfalls, and any object in which a break in length would increase the scale. Another device to attain magnitude was the repetition of parts: in a single mountain, size often resulted from the knowing manipulation of the wrinkles; and in the typical Northern Sung designs, mountains were piled up and up until, like the repeat of theme in a Bach fugue, the very multiplicity created a sense of immeasurability.

Here we are on the threshold of a psychological scale so very different from our own that we are puzzled by it. In the west psychological scale was measured by man's awareness of himself. In Egypt, where the individual counted for nought, the scale or lack of scale was oppressive; in Greece it was made human and became measurable; in China not man but nature was the measure, and that nature was uniquely conceived as the symbol of the universe. Consequently, psychological scale in China dealt with the incommensurability of nature. In lateral design, the enclosing and limiting effect of the frame was nullified by having the design

begin with a detailed treatment of "cooling streams, split mountains, crooked trees and tortuous woods," and then "towards the sides the views should be open, and the ranges and ridges 16 linked together should vanish in the distance." In such a design the spectator begins with the limited and measurable and then is carried into the unlimited and incommensurable.

WHATEVER the relative merits of the eastern and western approach to space, distance and scale, we must admit the supremacy of the Chinese in design within the picture plane. Their moving focus and quest for unbounded space both acted to destroy the boundaries of the frame, and yet at the same time they were able to achieve the most perfect relation of the surface design to the format of the picture. This is difficult for us to understand because we have relied so completely on axial balance and geometrical schemes for our surface unity while the Chinese have resorted to temporal coherence and consonance. Balance, especially symmetrical balance, has accounted for the static quality of many European designs, and the discovery of perspective with its restriction of visual space and single focus tended to emphasize vertical and horizontal axes. In a typical Renaissance or Post-Renaissance design a part or interest on one side of the picture will be balanced by an equivalent part or interest on the other side of the picture. This weighing of interests as if in scales must necessarily seem static and confined to the picture format; to counteract this, dynamic movement was achieved by turning the pictorial planes and axes of the solids diagonally in depth. The Chinese reversed this procedure; they usually kept their pictorial planes parallel to the picture plane and achieved their dynamic movement by the lateral flow of planes in succession. In one, the mind weighs the balance of distant parts across an axis, and in the other the eye follows the integration of one part with the next. This did not mean that the Chinese were unmindful of the merits of balance because most designs, particularly in the album pieces, can be analyzed in terms of asymmetry; however, the asymmetries played a secondary role since they were weakened by the absence of strongly asserted axes and since they were masked by the lateral movement of the sequences. The supreme expression of such movement was called lung-mo (dragon veins). As in most Chinese conceptions, this term was widely applied to every situation which involved the connecting arteries of the design. It referred to the coherence implied in the rhythms of the wrinkles (tsun), as in "Wang Mêng who used dragon veins (lung-mo) abundantly, making them like winding snakes, or in Wu Chên who painted them like straight lines." "Make the dragon veins slanting or straight, complete or in fragments, hidden or visible, broken or continuous, but all bristling with life, then you will make a real picture." Rhythmic abstraction and rhythmic relation being inseparable, the notion of lung-mo was extended to the flow of the whole design. Chao Ts'o uses the phrase shih li (structural principles): "Mountain slopes may be interacting, yet they are not confused. Why? Because they have their principles (li). The manner of making the wrinkles, of drawing the outlines, of dividing and combining, is all in the shih li." The dragonlike flow of the design was most clearly analyzed by Hua Lin in his discussion of the relation between shih and ch'i and between solids and voids. "In the empty places of the whole format we should be especially careful. If the shih or structural integration, which needs a wider space, is narrowed then the ch'i is restrained and restricted; if the shih, which needs a narrow space, is widened then the ch'i is lax and dispersed. It is necessary to make the empty places of the whole body neither restricted or restrained, nor scattered or dispersed, nor extremely

solitary like stars or repetitious like teeth, and then the empty places of the whole body will immediately be the lung-mo."

If Chinese painting is an art of time, if its unity depends more upon coherence than upon balance, and if the designs are characterized by lateral movement, how were these frame destroying qualities held in leash so that we will grant supremacy to the Chinese in their feeling for the shape of the format? In general, four chief methods should be mentioned: the timing of sequences, the use of stopping places, consonance, and tension. Timing, as in musical *15* composition, was all-important in the long scrolls. We ever marvel at the masterly use of accelerandos and ritardandos in the spacing of landscape elements, at how deliberately the rock and tree themes are first stated, how they are swiftly multiplied, and then slow down into long passages of shore line, stretches of water, or reeds and grasses, and how all of these tempi are combined with crescendos and diminuendos, how the artist will pile mountain range on mountain range in a resounding counterpoint until they fade away into mist or fog, mere whispers of the continuous music of the landscape. In a scroll, the crucial moment of adjustment to the format will come at the very end; and the close will be handled in a great variety of ways, but always tied up with the timing of the sequences. Since the Northern Sung masters composed with strongly stated forms, they preferred a formal close on the main theme after a brief transition; since the Southern Sung men were dealing with the obliteration of form, they usually allowed their scrolls to die away into nothingness with subtle sequences of descending mountain ranges or boats spotted against the void of a river. Later artists were apt to try for new and more startling effects. Wang Hui after a ritardando and diminuendo often closed a scroll with an emphatic motif like a resounding chord. In dragon scrolls the speed of lateral movement might be so swift that the full stop of a vertical cliff would be used to prepare for the final passage; while in flower painting only a single arresting note such as a new motif or spot of color would be sufficient. In tall hanging paintings emphasis and harmony played a larger part in adapting the forces to the format, because all four sides of the rectangle *19* created special problems and the more cramped area made the timing of sequences more intractable. With what consummate skill the Northern Sung master checks our wanderings through the mountains by a waterfall or temple at the sides of his picture, so that, although the design seems to continue on beyond the frame into unlimited space, our interest is turned back to renewed wandering. We can only appreciate the finesse of these designs if we compare them with the later Ch'ing copies where the wandering eye is carried along a spiral up the center of the picture and the elements at the sides rigidly repeat the verticals of the frame, or if we compare them with the rather obvious framing of most western designs. At the bottom of the picture the earlier painters were mainly interested in the handling of the *16* *repoussoir*; later in Ch'ing times the lower portion was left blank to speed the spectator into *28* depth, and then the amount of void had to be carefully measured. Perhaps the most difficult situation arose in Ming designs when the artists often tried by the use of waterfalls or cliffs to imply space below the frame and, at the same time, to carry the spectator into the painting.

Because of the use of voids instead of painted skies dotted with clouds, the Chinese artist

had to estimate the amount of void needed to absorb the forces of movement or to establish an equilibrium of tensions,—a feat of design so much more difficult than the western balance of cloud forms with earth forms across the horizontal axis of the horizon. In the circular and melon-shaped album pieces the Chinese displayed their mastery of design within the picture plane. A survey of the Renaissance tondi will demonstrate the intractability of balance and perspective when faced with troublesome area relationships in contrast to the adaptability of coherence and moving focus in dealing with unusual formats. The principle of consonance also came to the aid of the artists by furnishing repeats of the curve of the format in the motifs of the design; and these repeats often slowed up sequential movement or established tension. Certainly tension was the chief means for keeping their round formats from spinning; if balance is used, the slightest mistake in weight will upset the equilibrium, but tensions work throughout the design to maintain its equilibrium. To get an analogous cohesion of the whole, the west has generally stabilized its designs by the use of geometric figures, especially the triangle or pyramid. Compare the equilateral triangle with the Chinese compositional principle of heaven, earth, and man, in which three features should be held in equilibrium like an ideograph, with heaven the tallest, with man the shortest and with earth intermediate. By the irregular spacing between three unequal features, a sense of naturalness is secured while geometric compositions are stable and obvious but utterly lacking in life movement. No Renaissance designer could have written: "Painting is like vapours and clouds which rise into space, gather around cliffs and drift over wide expanses producing an interplay of shadows and lights." Here is the flux of life itself translated into the interaction of pictorial solids and voids, of positive and negative areas.

THE relation between solids and voids will tax our aesthetic sensitivity more than any other problem in Chinese design. To know when a brush stroke has ch'i may seem baffling, but at 40 least the brush stroke is tangible and measurable. A void may be so indefinite that it defies all judgment; in fact, many Sung voids were meant to suggest the "mystery of emptiness." Such a conception has had no parallel in the west because our concern with actuality has made us emphasize the existent rather than the non-existent so that the sky was a space-filled realm and not a vehicle for imparting a sense of the infinite. Far from being a void, a typical Dutch sky is a painting of tangible cloud forms, defining a definite space. The clouds in Chinese painting belong to the mountains and most of the skies are empty voids, yet these voids may be 26 the most important parts of the design. Yün Shou-p'ing complained about his contemporaries of the late seventeenth century: "Modern painters apply their mind only to brush and ink, whereas the ancients applied their minds to the absence of brush and ink. If one is able to realize how the ancients applied their minds to the absence of brush and ink, one is not far from reaching the divine quality in painting."

This is not a matter of technique, since empty parts, in the sense of space free from the touch of the brush, will normally not appear in our tempera, fresco, or oil techniques but only in such techniques as drawing and water color. The crucial question is what these empty parts signify. An area of white paper in a Sargent water color will describe a measurable amount of space as effectively as if it had been fully painted. The nature of the void determines its design value. In depth design we have already seen how every void represented a kind of space and how the use of the three depths made Chinese space more incommensurable. In two- 15 dimensional design every void is an area with defined boundaries, and therefore we might suppose that it served in the design merely as a measurable unit. That would be true in pure decoration or in illusionistic painting in which the blank areas counted according to their size; but in Sung design the empty parts counted according to their character, and the character of Chinese empty parts was influenced by a unique cultural conception of void, based on the Taoist speculations about the significance of the non-existent. To understand such an attitude 22 toward emptiness we must examine the historical factors which made it inevitable.

Historically the conception of empty parts evolved in all civilizations from an ideational neutral background to a more visual representation of space. In early painting ideational mentality had eliminated everything except the essential figures, while the empty places had no representational meaning and a limited design value. The Han bas-reliefs exhibit the skill of the early artists in combining the shapes of figures and areas of neutral void into pleasing 2 and sequential patterns; the Han lacquer paintings and the Ku K'ai-chih scroll illustrate the 4 use of the neutral void as a relief for the figures. The Chinese feeling for the need of voids as amplifiers remained a characteristic trait throughout their history: "The picture should be empty at the top and at the bottom and spacious at the sides, so that it looks agreeable. If the whole format is filled up, it no longer has any expression." In the T'ang and Northern Sung

periods, the empty places began to represent space, which became the vehicle of seasonal and

16 atmospheric moods; "Mountains without mist and clouds are like spring without flowers and grass." But as long as the T'ang and Northern Sung artists depended upon the solids of the mountains to establish their space, the voids served chiefly to increase the scale of the solids or to suggest depth. It was only when the solids began to be obliterated in Southern Sung times

21 that the voids reached their final significance. The vastness of nature was no longer conveyed by a multiplicity of solids but by the quality of the void,—a void which was never mere atmosphere but the vehicle of the ch'i spirit. Speaking of the old pictures, Li Jih-hua said: "Such pictures may contain a great many things without being crowded, or only a few things without being scattered or thin; they may be thick without being muddy or dirty, or thin without being empty or unreal. That is what may be called spiritual emptiness or the mystery of emptiness." Qualitatively the void is here the symbol of "that non-existent in which the existent is," and quantitatively the voids have become more important than the solids. In both respects the whole relation between solids and voids must be experienced through new eyes of the spirit; only then will we be able to grasp the extent of void needed to hold a given solid in equilibrium. Our aesthetic awareness may be tested by comparing a Sung monochrome with a Ming or Ch'ing copy in order to observe the kind of void suggested by the obliteration of the solid and to judge it as an area in the design. In a Sung original the concrete fades away into nothingness by the most subtle gradation of ink washes the world has ever seen, so that a small solid, a tree group, a single tongue of land, or a middle distance cliff will suggest such

22 a transition from the finite to the infinite that a vast extent of void will be needed to satisfy the solid. The same solid rendered in the mottled washes of Ming, which represent more

26 naturalistic texture and light, will seem so concrete that it will demand only a natural amount of mist filled space; or, if rendered in the hard treatment of Ch'ing, such a solid will imply

32 so little space that the void will become inexpressive blank paper and its size will depend upon its use as an area in a decorative pattern. How many Ch'ing solids look like insignificant specks on an expanse of white paper! The void has lost its ch'i significance and therefore the design relationship of solids and voids has been upset. No wonder a Ch'ing master said, "If the empty places are right, the whole body is alive, and the more such places there are, the less boring the whole thing becomes; if one ponders over this, one may learn to understand the marvels of the 'carefully planned designs' of the old masters." The emptiness must be alive. Ch'i may reside in an ink wash as well as in a brush stroke, in white paper or in silk, and it sets up forces of movement and tension which must be resolved in a dynamic equilibrium of solids and voids.

In all design relationships, both east and west, the most crucial problem is the coordination of design in depth with design in the picture plane. How many European designs have been broken up by deep perspective vistas or have suffered from unfortunate juxtapositions of the near and the far! By contrast, consider the words of Shên: "In a profuse composition, thick and light need one another and thus the Tao principles are established; in a sparse composition, far and near need one another and thus the realm becomes expansive." That is, each

situation must be handled according to the profound principles of design which were ultimately based on the Tao—the fruits of ch'i, the unities of k'ai-ho, yin-yang and consonance, and the equilibrium of tensions. Perhaps the most distinctive and the most effective means for coordinating surface design with design in depth were "brush and ink" and voids. Through "brush and ink" the Chinese could maintain a perfect harmony between the near and the far; and through voids they could establish intelligible measure between motifs in depth and in the picture plane, while at the same time the voids being ch'i in quality created a sense of intangibility and mystery.

19

DESIGN AND DECORATION

In content, the west has erroneously claimed that Chinese painting is romantic, not realizing that the romantic approach to experience is based on the divorce between actuality and longing, whereas the reality of the Tao resides in the fusion of opposites. Stylistically, an analogous confusion has existed in our minds concerning the relation between design and decorative values. We have been inclined to belittle Chinese painting because it seemed more decorative than western painting, not appreciating that the Chinese have been more sensitive to design values and that design values involve decorative principles. Once we grasp the relationship between them, then the word decoration becomes shorn of its derogatory tone, which it has acquired both by the western attitude toward the decorative and by the decorative element in decadent mannerisms. A decorative effect may arise from many causes: from use as in the decorative arts of screens, porcelains, or lacquered utensils; from the attitude of a period, as in the Ch'ing emphasis on design values under "art for art's sake"; from the decline of creative energy resulting in over-stylized motifs and automatic repeats, as in late Tun Huang paintings or again in the nineteenth century; and, finally, from the orientation of the culture, as in Islamic art. It is in this last sense that we have accused Chinese painting of being decorative. The chief qualities which produce a decorative effect are stylized rhythm, harmony of rhythms, two-dimensionality, area relationship, non-natural color, and repetition of motifs; the very listing of these qualities brings the startling realization that they are the most patent characteristics of Chinese design. But when we compare the presence of these qualities in Chinese art with their use in Byzantine art or in Japanese art, we recognize how different the Chinese were in their intent. The question is not whether decorative qualities are present, but what they signify. What motivated the stylization? Why was consonance sought? How were the motifs repeated? It has already been pointed out that, although a Sung landscape possesses these decorative principles, decoration is the last word we would ever apply to Sung design because the decorative and representational qualities have been so completely fused by the more profound purpose of painting the Tao.

The fusion of decorative and representational values was perfected by the gradual historical development of Chinese design values from the principles of their ideational past, in which the potentially decorative qualities of stylization, area relationship, and repetition were the most striking traits because of the simplified and uniform rendering of natural appearances. The representational and decorative were absolutely blended so that the same line which defined the shape of a figure also possessed a high degree of decorative stylization, and the arrangement of figures formed a pattern of areas while indicating an episodic scene. It has already been pointed out how the problem of plastic form was solved in a Chinese way by the thickening and thinning brush of Wu which could suggest plasticity while keeping rhythmic line, how the problem of spatial depth was solved by an echelon of vertical planes, instead of by foreshortened ground planes, so that areas became fields of tension between solids and voids, how the ideational use of a few motifs was turned into a method for symphonic effects

of repeated motifs, and finally how the decorative similarity of rhythms developed into con- 23
sonance. By the thirteenth century, Taoistic speculation upon the nature of the universe had
so transformed the decorative qualities that they lapsed into a secondary role before the
principles of design. The reverse of this process happened in the Ming and Ch'ing periods and
resulted in the gradual suppression of Sung principles by the decorative tendencies for their 28
own sake. However, instead of being fused with the representational qualities as in ideational
decoration, this late or manneristic decoration was divorced from representation. Like a
beautiful creeping vine it covered the tree of natural truth and in the nineteenth century
virtually smothered that tree. When lines of drapery assume ornamental twists and change
direction ten times, or when drapery folds interpenetrate quite arbitrarily, or when scarves
end in calligraphic flourishes, they become functionally meaningless; and when areas of solid
and void disintegrate into patches of pattern, they cease to suggest a spatial realm. Under the
spell of the doctrine of "art for art's sake," which seems to plague every late period, decoration
became an end in itself, so that a painting was merely a piece of decoration.

In the growth of each civilization it is axiomatic that the cultural traits tend to assert them-
selves increasingly until they are strained to the limit. The scientific interest of Europe will
end in optical realism; the ideographic approach of China will produce the "literary man's
painting" (wên jên hua). The cultural quest for the essence of the idea produced an extreme
simplification of the motifs despite the ever growing interest in the diversity and complexity 25
of nature. The cultural association of painting and calligraphy meant that the rhythms would
become more uniform, cursive, and ornamental, finally reaching the tour de force of drawing
the god of literature in the likeness of his ideograph, or of arranging the leaves of a bamboo
in ideographic characters. However the tendency toward stylization of rhythm was relieved
by the playfulness of the Taoist spirit. Where "art for art's sake" in the west meant design
values devoid of content, in China it more often resulted in technical eccentricities. The tech- 27
niques, instead of the design principles, became ends in themselves and resulted in the de-
lights of ink flinging and finger painting. 31

The traditional habit of seeing things as shapes led to an emphasis on area relationships
which must eventually result in mere pattern. In some ways this was more fatal to ch'i than
the calligraphic stylization of the rhythms because the static effect of pattern counteracted the
principles of moving focus and tension and replaced them with frame consciousness. As soon 28
as Chinese design subjected itself to the frame, certain principles appeared which have been
the chief supports of western design,—namely, balance, geometrical relationship, and com-
positional lines which repeat the lines of the frame. The unlimitedness of space became
confined, while the flux and freedom of nature was supplanted by the order and decorative
effects of geometry. Chou I-kuei said: "A picture must be in congruity with the shape and
size of the paper on which it is painted. It should resemble the form of a right-angled triangle
with legs of unequal lengths, leaving parts of the paper blank either at the top or at the bottom,
on the right or on the left." One of the most striking corollaries of frame consciousness was
segmentalism, in which the frame cuts an object so that only a section is shown whose area

may assume a more decorative shape. The Japanese print makers especially delighted in this device, which in China appeared rarely in painting and was reserved for the purely decorative arts. How illuminating it is that the Chinese should have invented the wood-block print and then, instead of developing its decorative potentialities, defied its restrictions to the point of retaining the living quality of the brush medium in the wood-block plates for the "Ten Bamboo Hall" and the "Mustard Seed Garden."

Lastly, the scholarly character of Chinese painting meant that technically it would depend on "brush and ink." This restricted the use of color both representationally and decoratively. The Chinese lack of interest in natural color, except in the painting of flowers where the color may be the essence of the idea, is delightfully indicated by a story about ink bamboo. Someone asked the painter why he painted his bamboos in red, and when the painter replied, "What color should they be?" the answer came, "Black, of course." Monochrome, though non-natural in color, has very little decorative appeal for us since we are so accustomed to associate decorative effect with the strong, brilliant color of Rubens, or with the pale neutral tones of Puvis. Both of these extremes appeared in Chinese painting, one in the blue, green and gold style of Li Ssŭ-hsün and the other in the Ming palette so heavily mixed with white. On the whole, however, decorative color belonged rather to the Japanese tradition, being inherent in the Yamato-ye style and reborn in the great decorators and print masters. To the Chinese scholars the use of colors verged on the common—"the vulgar painter uses color," although Chang Kêng, of the eighteenth century, excused the Sung and Yüan masters, saying: "Many ancient artists excelled in blue and green coloring. Can they be called artisans? Their high or low standing does not depend on the painted works but on the ideas." That is, the test of the effect of rhythmic stylization, area relationship, consonance, repetition of motifs, and non-natural color lies not in the use of these decorative means but in the intent behind them. In Japanese screens and wood-block prints both the intent and the means were decorative but were vitalized by the survival of Chinese life-movement and tensions. In Chinese painting, especially during the Sung period, the design values were garments of the "ideas."

SIMPLICITY, EMPTINESS AND SUGGESTION

THE Chinese quest after the Tao implied something more than the most subtle and perfect design values. The importance of yün (resonance), with its rules and methods, assured great sensitivity to design values, and these values, in so far as they manifested the order and harmony of the universe, were vehicles for conveying the Tao; however, yün (resonance) was ever secondary to ch'i (spirit). As Shih T'ao put it: "The method is complete when it is born from the idea, but the method of the idea has never been recorded." In trying to express the unnameable ideas (miao i), the artist had to experience a communion with the mystery of the universe akin to that enjoyed by the Taoist "mystics." Accordingly, the creative process was described in terms of emptiness, simplicity and suggestion; and the painting itself presented a unique relationship between the known and the unknowable.

In the words of Li Sih-hua: "That which is called ch'i-yün must be inborn in the man. It is indeed in a state of emptiness (hsü) and tranquillity (tan) that most ideas are conceived." And when the ideas are carried out, the brush must possess the power of spiritual suggestion through emptiness (hsü); hsü meant that the "brush comes to an end but the idea is without limit (wu chiung)." Furthermore, "in employing the brush, it is necessary that every brush should hold within itself pictorial reality (shih) and yet at the same time emptiness (hsü), for by being empty, then the idea becomes spiritually alive (ling); by being spiritually alive, there is no trace of obstruction (chih); by being not obstructed, then there is wholeness of spirit (shên-ch'i hun-jan); by being hun jan, then it is a heavenly creation (t'ien-kung)." The term, hun, is here used in the cosmic sense of Chuang Tzŭ, to signify the creative entirety and potentiality of primeval origins, quite different from the motion of confusion inherent in the western conception of chaos.

This description of artistic creation reveals the distinctive character of Chinese painting in contrast to the European practice. Because of our inclinations toward reason, science and the expression of human emotion, it was inevitable that western painting should depend on forms. In these forms we have valued intelligibility, convincing representation and emotional expressiveness. Solid permanence has been preferred to the intangible. In China the emphasis on intuition, imagination and the moods of nature led to the importance of the mysterious, the intangible and the elusively expressive. Both east and west sought reality, but in one, the universal truth was to be captured in the forms, and in the other, the mystery resided in the forms and in something beyond the forms. The painter begins with the pictorial reality of shih, then suggests through hsü (emptiness) the reality of the spirit beyond form, with a flow and effortlessness which results in the indescribable unity of hun. We pass from the tangible and measurable into the intangible and incommensurable and yet experience the intelligibility of the whole which, at the same time, is the wellspring of the mysterious.

This conception of artistic creation was most completely realized in the ink paintings of the Southern Sung period, coincident with the rise of extreme introspection. That is why we instinctively refer to these subtle monochromes when trying to fathom the Chinese spirit.

[77]

They most perfectly embody the speculation about the Tao and, therefore, they can never be understood in terms of western spirituality or romantic mystery or the "spell of space." This is not our kind of form nor our kind of space. In the most vague and evanescent paintings of the west, our experience of reality is rooted in visual appearance. In these Chinese paintings we are mystified and enraptured by forms which are so simplified that they become intangible or so obliterated that they suggest emptiness which is non-spatial. The relationship of solids and voids defies analysis whether in the picture plane or in depth. It is not easy to estimate the unity of a design made up of tangible and intelligible forms; it is almost impossible to grasp the unity of such incommensurables. These Chinese paintings suggest a state of flow and relativity between the seen and the unseen which is a kind of symbol of the operation of the Tao.

CATEGORIES OF GREATNESS

THE Chinese categories of greatness summarize their approach to painting. Although no single classification was accepted as the standard, they all agreed in ranging the grades of excellence from mere formal beauty up to the greatness of profundity. In general, four levels in the ladder of greatness were distinguished which roughly corresponded to four levels of human development; namely, formal skill, cultivation, wisdom and spiritual insight. Just the enumeration of these reveals the Chinese insistence that painting is the creation of the whole man and therefore greatness must depend upon the artist's philosophy of life in its imaginative penetration into the soul of humanity.

At the lowest level, variously termed nêng (competent) or chiao (clever), the painter had acquired skill and knowledge of the rules of style. By hard work he can render the "outward formal likeness" and can follow the "rules." The highest goal attainable at this level was a pleasing formal beauty, which Ching Hao deprecated—"the skillful painter carves out and pieces together scraps of beauty." "Fruit (shih) is not enough, yet flower (hua) has surplus." Although the Chinese have always insisted upon the perfection of techniques and design values, they never forgot that art was the vehicle for man's inmost thoughts and deepest inspiration.

The second level of experience, that of the cultivated painter, was characterized by personal taste. The painter had passed from acquiring and assimilating knowledge about his art to imbuing that ability with individual and expressive power. The writers, who termed this the ch'i (unusual) level, criticized the use of personal distortion. "The ch'i painter draws vast outlines, which are not in accordance with the truth of the motif; the things he makes are strange, queer and have neither reason nor resemblance. This is the result of having brush (pi) but not thought (ssŭ)." That is, the selectivity of thought (ssŭ) should be based upon something more than personal taste. Some writers called this second level miao (wonderful). "Painting is done by men, and every man has his own natural disposition. The brush work may be fine and the ink wonderful but one does not know why it is so." In this statement, the genius of the individual was recognized but the emphasis was not on personal expression. "This manner is transmitted from the mind to the hand and exhausts the subtlest mysteries."

Artistic truth was the goal of the next level of attainment, sometimes termed miao (wonderful), and at other times, shên (divine). A "divine" painter "penetrated with his thoughts the nature of everything in heaven and earth, and thus the things flow out of his brush in accordance with the truth of the motif." At this level the "inspiration of heaven is very high" and "the thoughts harmonize with the spirit." Here the scholar-artist, through the breadth and depth of his character, begins to have "an understanding of all things." When an artist reached this divine level it would seem that nothing higher could be postulated and some critics stopped at this grade. However, in view of what has been said about the Tao and its manifestation in ch'i (spirit), a still higher conception of greatness was inevitable.

The fourth and supreme category of excellence defies definition. The same term "i" or effortlessness, which we encountered as the first fruit of ch'i (spirit), was also used for this highest level of experience because it most nearly suggested the relation between artistic creation and mystical oneness with the Tao. The "i" painters "grasp the self-existent, which cannot be imitated, and give the unexpected." They were absolutely free and natural. Some Chinese writers questioned whether this grade should not be put at the bottom rather than at the top of the ladder, since they failed to distinguish between the freedom of license and the simple effortless creation of the Taoist recluse. This kind of excellence can only be found in the seers, the saints and the greatest artists. We recognize it in a person in whom we are aware of a rare presence, a pure creative force, or an untrammeled spirit. Perhaps untrammeled is the one word which comes closest to suggesting this ultimate quality. If the rules have become second nature to the painter, if he can lose himself completely in the conception, and if he has attained depth and breadth of character, then he is ready to aspire to that highest kind of freedom, the freedom of effortless creation. Then the imagination enjoys most profoundly the immediacy of the "wedding of spirit and matter."

LIST OF TERMS

A. BASIC CONCEPTS

氣	ch'i	spirit
韻	yün	resonance

B. FRUITS OF CH'I-YÜN

自 然	tzŭ-jan	naturalness
逸	i	effortlessness
理	li	universal principle
思	ssŭ	thought
意	i	conception
實	shih	pictorial reality
景	ching	seasonal aspect
骨 法	ku-fa	structure (bone-means)
勢	shih	structural integration
生 動	shêng-tung	life movement
筆	pi	brush
墨	mo	ink

C. PRINCIPLES OF DESIGN

Chinese substitutes

unity		
contrast		
coherence	開 合	k'ai-ho
emphasis		
balance	陰 陽	yin-yang
equilibrium		
consonance		
proportion		
scale		
sequence	龍 脈	lung-mo
	起 伏	ch'i-fu

[81]

LIST OF SOURCES

Pre-T'ang and T'ang Periods
 Chang Yên-yüan: Li-tai ming-hua chi.

Sung Period
 Ching Hao: Pi-fa chi.
 Kuo Hsi: Lin-ch'üan kao-chih.
 Kuo Jo-hsü: T'u-hua chien-wên chih.
 Liu Tao-ch'un: Shêng-ch'ao ning-hua p'ing.
 Han Cho: Shan-shui ch'un-ch'üan-chi.
 Hsüan-ho hua-p'u.

Yüan Period
 Li K'an: Chu-p'u.
 Huang Kung-wang: Hsieh-shan-shui chüeh.
 Jao Tzǔ-jan: Hui-tsung shih-erh-chi.

Ming Period
 Wang Shih-chêng: Wang-shih shu-hua-yüan.
 Tung Ch'i-ch'ang: Hua-yên.
 Wang K'o-yü: Shan-hu-wang.

Ch'ing Period
 Tao-chi: K'u-kua ho-shang hua-yü lu.
 Chang Ch'ou: Ch'ing-ho shu-hua fang.
 Tan Chung-kuang: Hua-ch'üan.
 Kung Hsien: Hua-chüeh.
 Wang Kai: Chieh-tzǔ-yüan hua-chuan.
 Wang Yü: Tung-chuang lun-hua.
 T'ang Tai: Hui-shih fa-wei.
 Tsou I-kuei: Hsiao-shan hua-p'u.
 Shên Tsung-chien: Chieh-chou hsieh-hua pien.
 Fêng Chin-po: Kuo-ch'ao hua-shih.
 Ch'in Tsu-yung: Hua-hsüeh hsin-yin.

The Republic
 Têng Shih: Mei-shu ts'ung-shu.
 Ma T'ai: Tsu-hsi hua-p'u ta-ch'üan.
 Ma K'o-ming: Lun-hua chi-yao.
 Hu Hsi-ch'üan: Shan-shui ju-mên.
 Yü Shao-sung: Shu-hua shu-lu chieh-t'i.
 Fu Pao-shih: Chung-kuo hui-hua li-lun.

INDEX

abstraction, 3, 8, 48, 59, 68
additive composition, 27, 52
allegories, 18, 21
ancestor worship, 11
ancestral portraits, 15
animate and inanimate, 5, 6
areas, patterns of, 74; relationship of, 28, 63, 75; spacing of, 37
art, 7; and religion, 5; and philosophy, 5; and Tao, 6
art for art's sake, 8
artifacts, 6
associations, 18

balance, 33, 54, 68, 70, 81
bamboo, 18, 19, 21, 22, 41, 42, 55, 57, 75, 76
being and not-being, 8
bird and flower painting, 25, 69, 76
brush, 26, 36, 37, 45, 46
brush pointing, 7
brush and ink, 43, 44, 71, 73, 76
Buddhism, 3, 11

calligraphy, 33, 36, 37, 43, 44, 45, 50, 75
categories of greatness, 79
Chang Ch'ao, 18
Chang Kêng, 76
Chang Yên-yüan, 12, 35, 36
Chao Ts'o, 37, 38, 68
chêng (frontal), 27, 50
ch'i (spirit), 35, 55, 81; and areas, 75; and beauty, 32; and design, 48; and its fruits, 34, 36-40, 44, 73, 80; and landscape, 64; and qualities of brush and ink, 45, 46, 47, 71; and the seasons, 15; and shih, 68; and voids, 72; and Tao, 79; and yün, 77
ch'i (unusual), 79
chiao (clever), 79
chieh (knotted), 45
chien-chia (spanning space), 48
ch'i-fu (rising-falling), 65, 81
ching (seasonal aspect), 19, 34, 36, 37, 40, 81
Ching Hao, 6, 14, 17, 19, 34, 35, 40, 47, 79
ching-ying (spirit-flower), 46
ch'ing (pure), 47

Ch'iu Ying, 12, 16
ch'i-yün (spirit-resonance), 14, 34, 45, 47, 77, 81
ch'i-yün shêng-tung (spirit-resonance life-movement), 38
Chou I-Kuei, 75
Chou Mu-shih, 21
ch'u (quality of appeal), 25
chuang (artisans), 37
Chuang Tzŭ, 8, 77
classic and romantic, 4
classifications, 6
coherence, 50, 68, 81
color, 28, 46, 76
communion, 20, 21, 22, 23
complexity, 25, 37, 41
composition, 8, 28, 52, 54, 72; and geometry, 31, 48, 54, 58, 70, 75
Confucianism, 4, 11, 12, 13, 14, 15, 26
Confucius, 7, 11, 14, 28, 31, 54, 56
consonance, 50, 52, 53, 54, 68, 69, 70, 73, 74, 81
content, 33, 55
contrast, 51, 81
culture and civilization, 24, 25
cultural traits, 3
cycles, 24

decorative, 44, 52, 72, 74, 75
decorative arts, 52, 74, 76
decorum, 12, 15, 18
design, 48, 54, 55, 59, 73, 81; and decorative values, 74; and moving focus, 6, 67, 68; and musical composition, 61; and solids and voids, 71
distance, 51, 57, 65
diversity, 25, 37, 41, 56
divine and human, 4, 11
dragon, 7, 10, 42, 69
drama, 17
drapery, 16, 26, 41, 43, 75; and its conventions, 19, 42
dualisms, 4, 5, 50

eccentricity, 14, 75
effortlessness, 13, 31, 45
elimination, 36
embellishment, 32, 38

emotions, 16, 18, 39
empathy, 33
emphasis, 81
emptiness, 8, 71, 77, 78
ends, 15
equilibrium, 47, 81; of forces and tensions, 38, 48, 54, 59, 70, 73; and movement, 42; and solids and voids, 72
essence of the idea, 29, 31, 35, 42
expressionism, 3, 31, 39, 44

Fan K'uan, 19, 21
finger painting, 75
fitness, 53
flux, 7, 8, 42, 48, 70
foreshortening, 59
form, 35, 36, 44
format, 68, 69, 70, 71
frame consciousness, 75
freedom, 13, 22, 45

God, 20, 24
ground plane, 25, 57, 64

Han Cho, 18, 21, 34, 36, 65
harmony, 5, 15, 20
heaven, earth, and man, 3, 9, 26, 34; composition, 70
host and guest, 21, 56, 66
Hsia Kuei, 22, 52
hsiang-hsing (formal resemblance), 36
Hsieh Ho, 12, 34, 36, 45
hsieh-i (idea writing), 37, 43
hsien (immortals), 9, 10, 18
hsü (emptiness), 77
Hua Lin, 36, 68
Huang Kung-wang, 14
Huang Shên, 16
humanism, 11, 12, 34
hun-jan (wholeness), 77

i (conception), 36, 81
i (effortlessness), 34, 80, 81
idea, 27, 36, 39, 76, 77
idealism, 28, 29, 30, 31, 44
idealistic painting, 4, 28
ideational, 29, 43, 52, 57; art, 27, 28, 30, 56, 61, 64, 71, 75; phase of history, 26, 34, 74
ideographic, 28, 33, 37, 59, 75

ideographs, 44, 48, 75
illusion, 51, 56
immediacy, 26, 28
inevitability, 35
ink, 44, 71
ink bamboo, 6, 25, 40
ink flinging, 75
intervals, 27, 38, 48, 57, 59, 60, 61
intuition, 27, 28
irregularity, 25, 37
isonomic, 52

k'ai-ho (open-join), 48, 50, 54, 55, 73, 81
k'o (carved), 45
ku-fa (bone-means), 34, 36, 37, 38, 81
Ku K'ai-chih, 12, 14, 16, 26, 27, 28, 43, 54, 71
Kun Ts'an, 22
Kuo Hsi, 6, 14, 18, 19, 40, 44, 65

landscape, 6, 7, 8, 20, 21, 23, 25, 28, 40, 50, 52, 61, 62, 63
Lao Tzŭ, 7, 8, 26, 28
law of five, 54, 55
learning, 11, 13, 18, 31
Lêng Mei, 39
li (universal principles), 13, 25, 34, 35, 37, 38, 39, 45, 69, 81
Liang K'ai, 16, 39
life-movement, 48, 58, 70, 76. See also shêng-tung
light, 25, 26, 28, 44
Li Jih-ha, 72, 77
Li Kung-lin, 12, 13, 43
Lin Liang, 42
Li Shih-ta, 14
Li Ssŭ-hsün, 6, 76
Li T'ai-po, 6
Liu Tao-ch'un, 45, 46
lung-mo (dragon-veins), 68, 69, 81

man and nature, 20, 21
mannerism, 31, 75
mao (hairy), 46
maturity, 14, 45
Ma Yüan, 22, 52
meditation, 20, 22, 27, 34, 35
mi (fine style), 38, 39
miao (wonderful), 79
Mi Fei, 15
mo (ink), 34, 36, 46, 81

modes, 19
moods and emotions, 17, 18, 25, 40
morals, 12
motifs and intervals, 57, 60, 64
mountains, 19, 20, 21, 22, 23, 37, 40, 51, 56, 65, 69, 71, 72
movement, 6, 7, 10, 25, 42, 48, 54, 59, 60, 62, 68, 69, 72
moving focus, 6, 62, 64, 68, 75
Mu Ch'i, 6, 23
multiplicity, 6, 7, 54, 55, 66, 72
mysticism, 5, 9, 11, 33

naturalism, 4, 29, 30, 39, 44
nature, 18, 20, 21, 22, 23, 24, 25, 31, 35, 41, 62, 66
nature, man and God, 3
nêng (competent), 79
Neo-confucianism, 4, 13
neutral backgrounds, 8
Ni Tsan, 15, 65
non-action, 51
non-existent, 8, 71, 72
nude, 40, 41, 42

obliteration, 7
Occult Taoism, 9, 10
opposites, 13, 46; fusion of, 4, 14; resolution of, 8
overtones, 12, 18, 22

pan (stiff), 45
personal and impersonal, 15, 16
personification, 21
perspective, 27, 62, 64, 70
pi (brush), 34, 36, 79, 81
p'ien (oblique), 50
plastic form, 25, 26, 37, 44, 74
poetry, 33
polarities, 4
portraiture, 15, 16, 28, 43
posture, 38
principles, 21, 25, 35
proportion, 3, 81

reality, 20, 23
reason, 3, 27, 28, 30, 31
rebus, 29
register system, 52
regularity, 25, 27
relationship, 44, 48, 59, 68
repoussoir, 65, 69
rhythm, 40, 41, 42, 43, 44, 48, 59

ritual, 11, 15, 17, 18
romanticism, 3, 20, 22, 23, 31, 33, 78

scale, 25, 28, 33, 51, 66, 72, 81
scholars, 18, 31
segmentalism, 75
sensuous qualities, 25, 30, 45
sequence, 6, 41, 57, 61, 62, 69, 81
settings, 56, 62, 66
shape, 27, 45
shên (spirit), 15, 37, 79
Shên Chou, 50
Shên Hao, 46
Shên Tsung-ch'ien, 13, 38, 48, 50, 60, 65, 72
shêng-tung (life movement), 34, 36, 40, 43, 44, 45, 81
shih (pictorial reality), 34, 36, 38, 39, 40, 43, 44, 79, 81
shih (structural integration), 34, 37, 38, 39, 68, 81
Shih T'ao, 77
simplicity, 14, 25, 27, 55, 56, 77
simplification, 36
solids and voids, 8, 68, 70, 71, 72, 74, 75, 78
space, 7, 28, 44, 61, 62, 64, 69, 71, 72, 78
spacing, 27, 56, 57, 58, 59, 60
spirit, 6, 7, 43, 49, 53, 58, 77
spirit and matter, 4, 5, 7, 8, 34
ssŭ (thought), 35, 79, 81
still-life, 6, 29, 30, 40
style, 13, 14, 33
stylization, 43, 44, 48, 53, 74, 75
suggestion, 31, 36, 40, 46, 77
supernatural, 9, 10

tan (tranquil), 27, 77
Tan Ch'ung-kuang, 21, 82
T'ang Tai, 47
Tao, 4-9, 11, 22, 23, 33, 53, 64, 78, 79, 80; and art, 4, 6, 7, 9, 33, 34, 73, 74, 77; and brush and ink, 44, 47; and flux, 7; and li, 35; and relativity, 59; and fusion, 8, 60; and yin-yang, 50
Taoism, 4, 9, 11, 13, 14, 15, 22, 23, 26, 51
Tao Têh Ching, 5, 26, 34
tension, 22, 31, 48, 60, 69, 70, 74, 75, 76; and equilibrium, 42,

48, 59, 70, 72; of opposites, 46, 47; and Tao, 8
texture, 28, 46
themes, 19, 25
three depths, 64, 66, 71
t'iao-li (position-pose), 57, 60
touch, 38, 44, 45
tradition and originality, 4, 24, 25
tranquillity, 15, 22, 25, 43, 77
transformations, 5, 48, 53
transmigration, 30
ts'ai (value), 47
ts'un (wrinkles), 19, 37, 42, 45, 60, 66, 68
Tung Ch'i-ch'ang, 37, 45, 56
Tung Yü, 5

tzŭ-jan (naturalness), 34, 47, 81

uniformity, 25, 27, 45
unity, 27, 33, 37, 48, 50, 52, 53, 54, 78, 81
unity and variety, 50

variety, 50, 51, 53, 54, 55
virtuosity, 44
voids, 8, 28, 41, 48, 57, 59, 69, 73; and depth, 64; and neutral background, 8; and solids, 8, 68, 70, 71, 72, 74, 78; and tensions, 42

Wang Hui, 23, 54, 69

Wang Mêng, 68
Wang Wei, 6, 22, 29
Wang Yü, 5
Wang Yüan-ch'i, 46, 50
wen-ts'ai (pattern of color), 47
Wu Chên, 15, 68
Wu Tao-tzŭ, 21, 30, 31

ya (elegance), 13, 27
yin-yang, 8, 13, 42, 47, 51, 52, 54, 55, 73, 81
yüan (distance), 65
yün (resonance), 14, 46, 47, 77, 81
Yün Shou-p'ing, 71

ILLUSTRATIONS

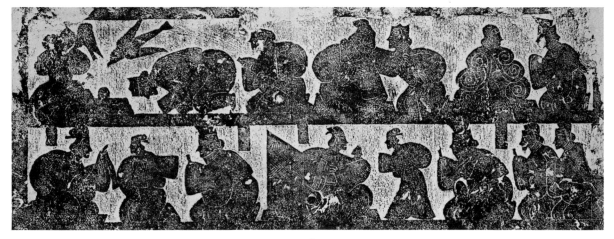

1

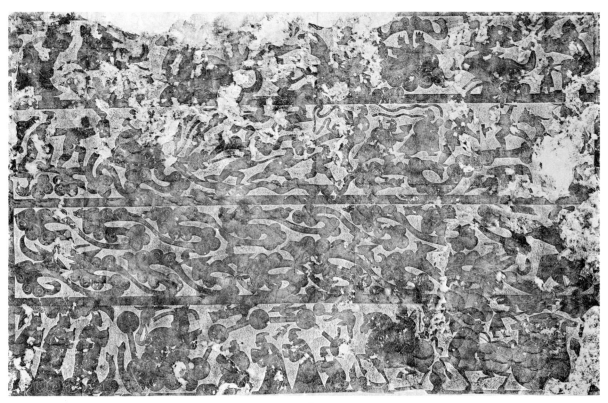

2

3

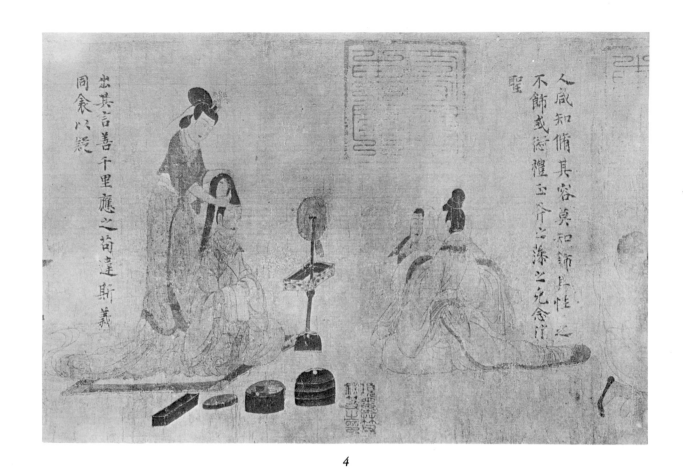

人咸知脩其容莫知飾其性之
不飾或愆禮正斧之藻之克念作
聖

出其言善千里應之苟違斯義
同衾以疑

4

5

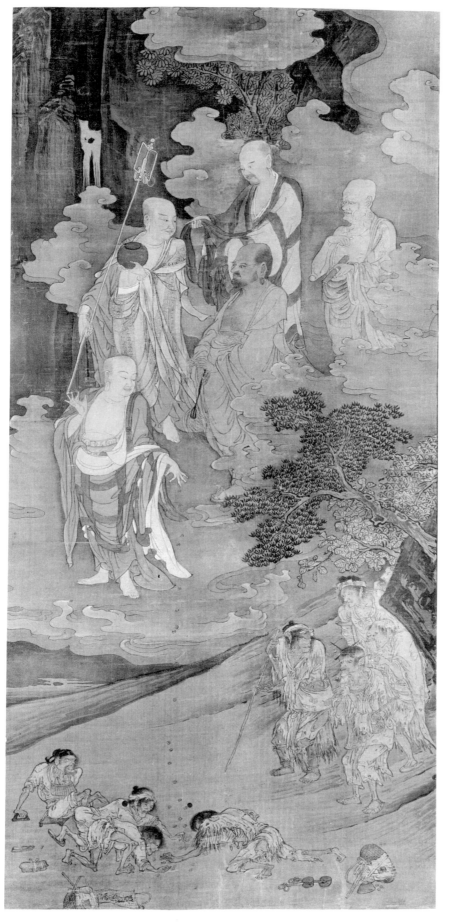

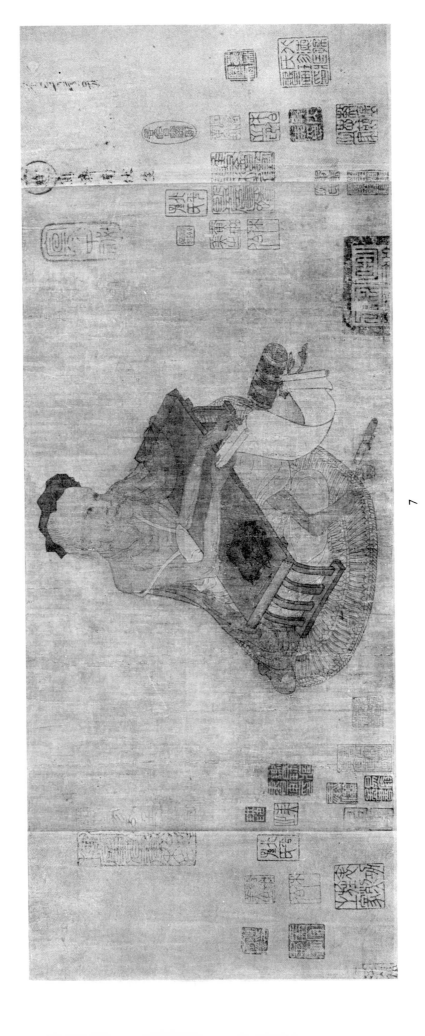

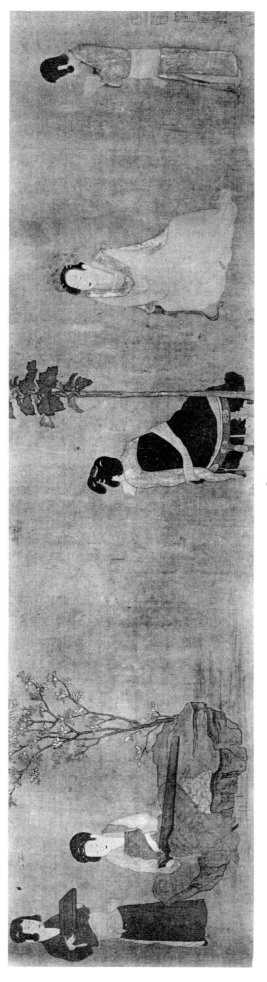

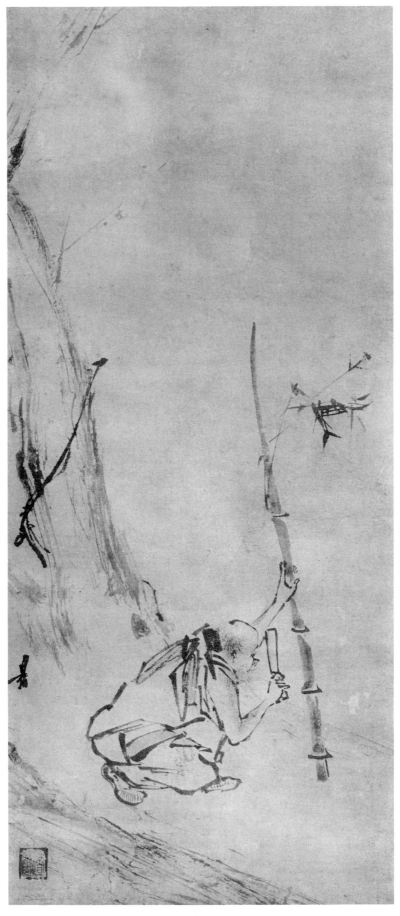

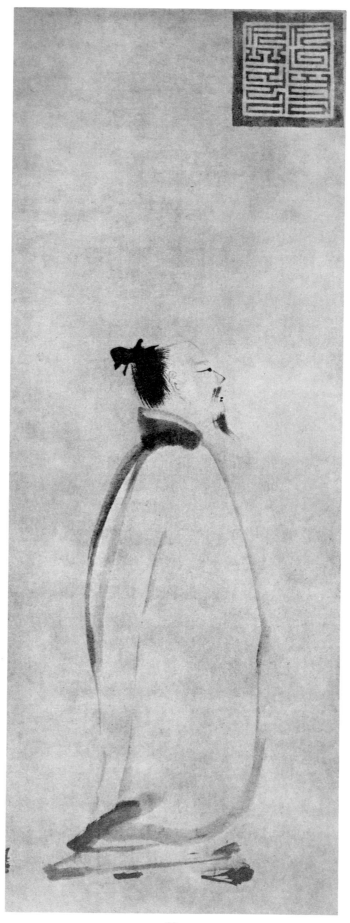

10

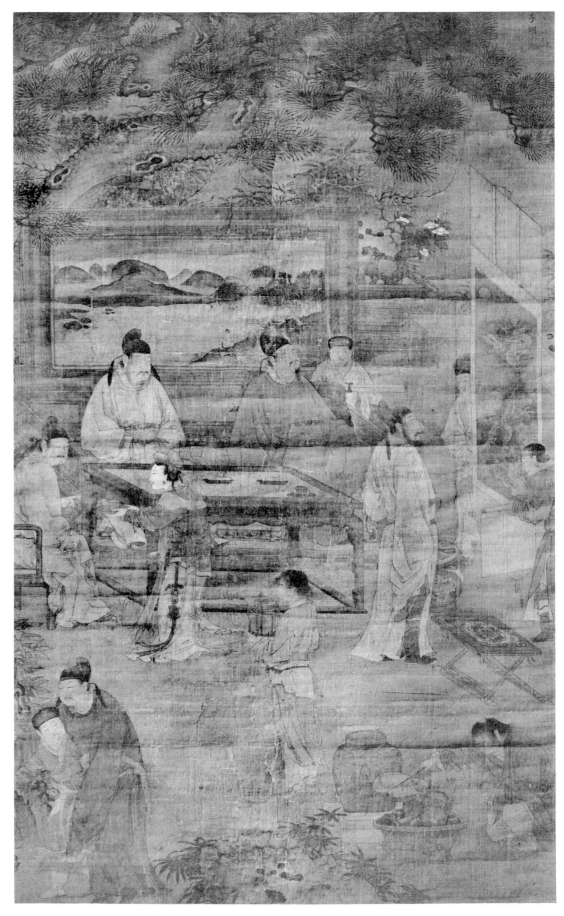

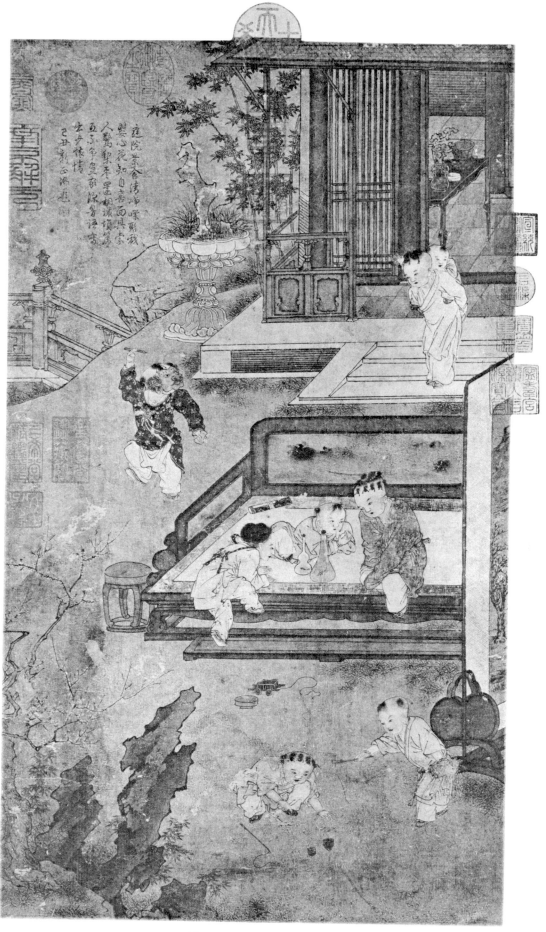

12

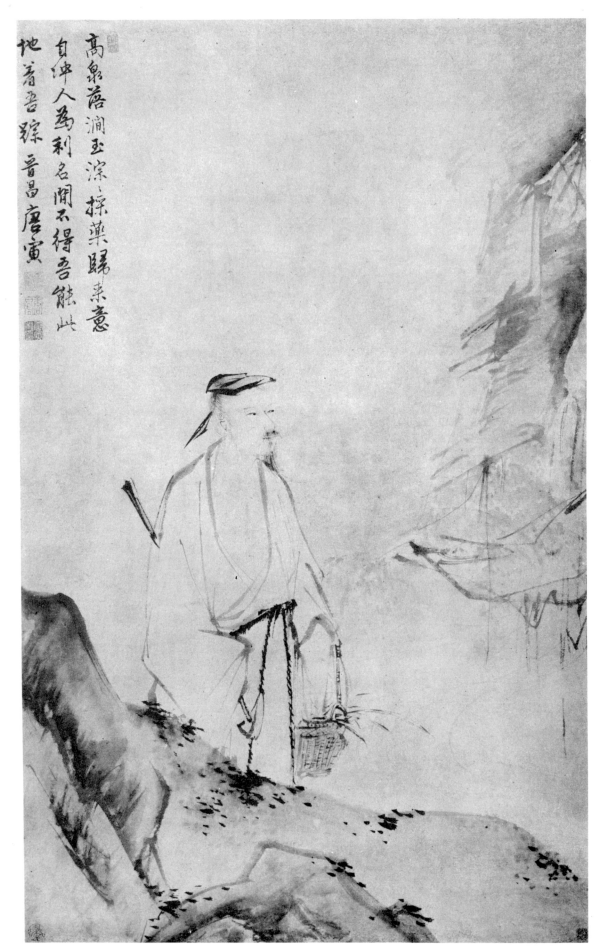

高泉落澗玉淙淙 探藥歸來素意
自沖人為利名開不得吾儕此
地着吾儕 晉昌唐寅

13

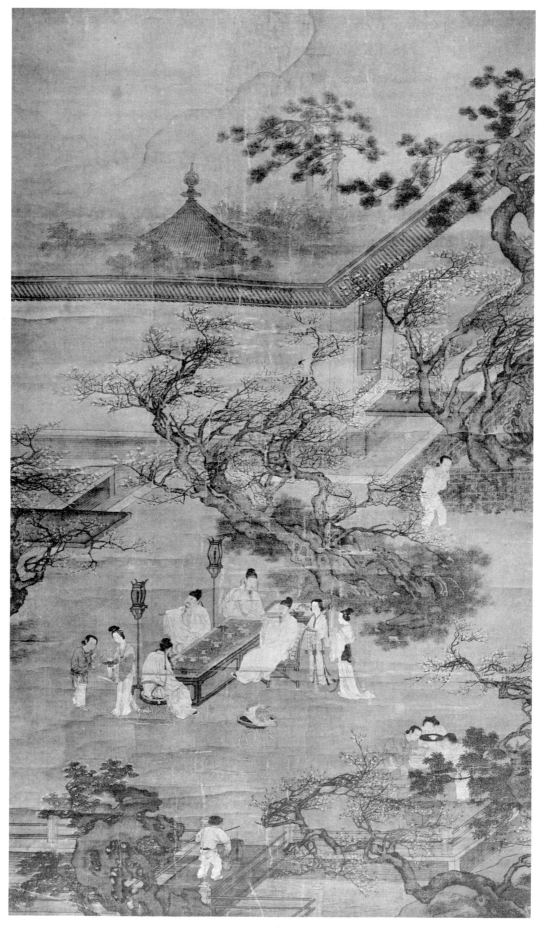

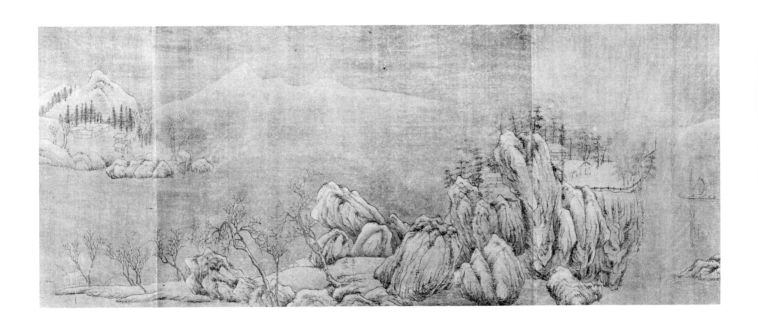

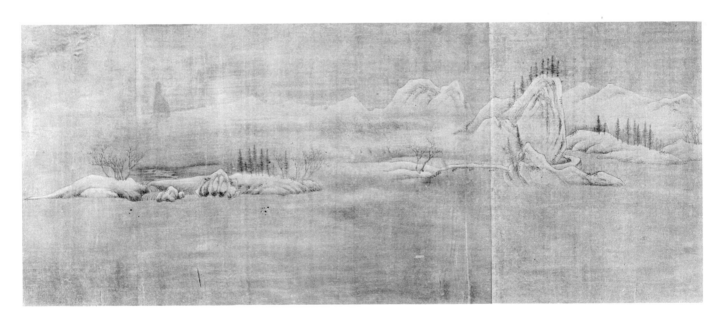

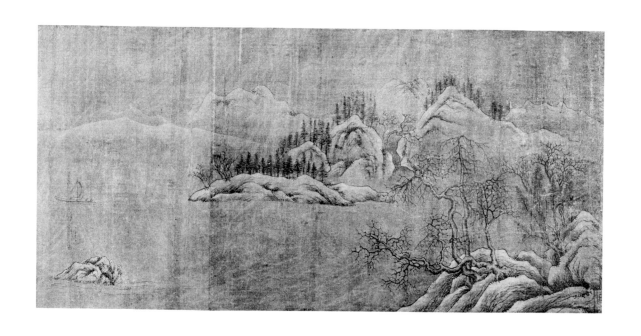

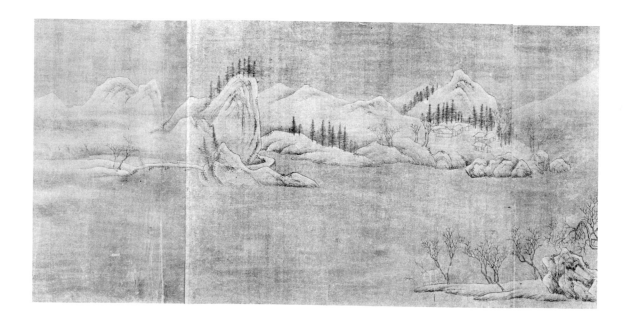

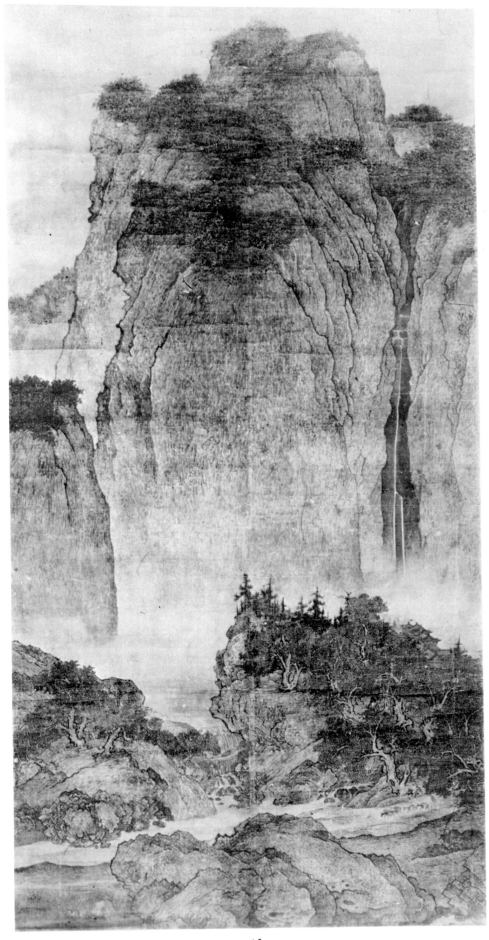

16

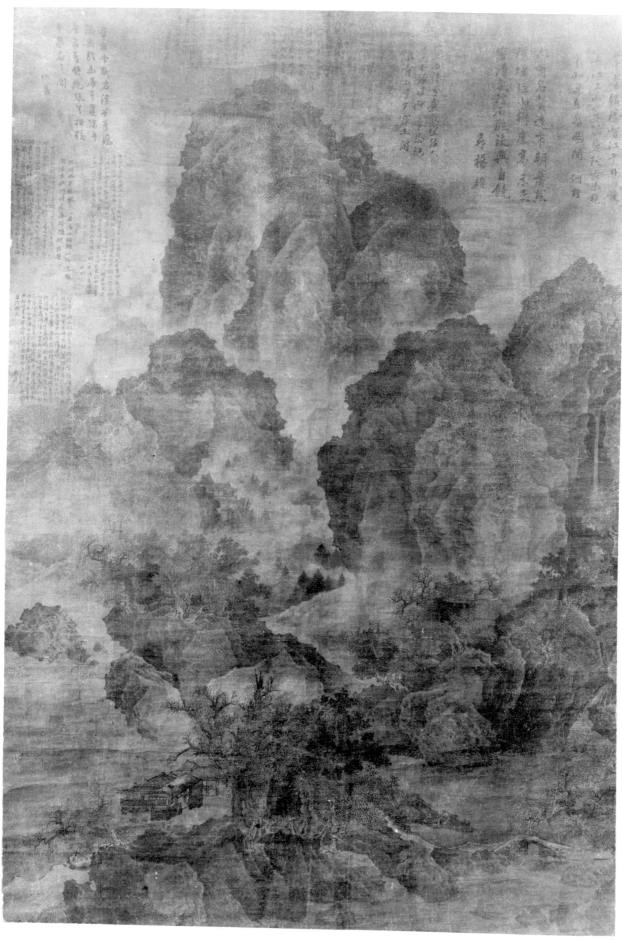

17

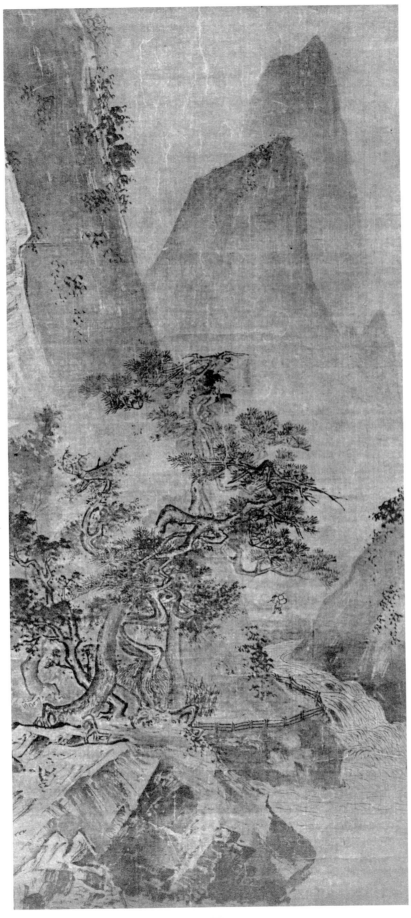

18

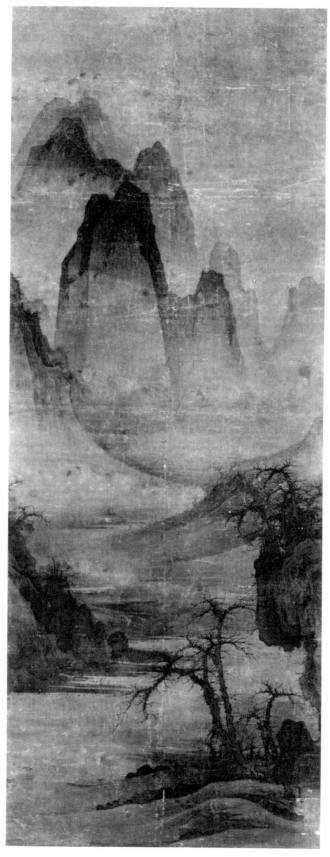

19

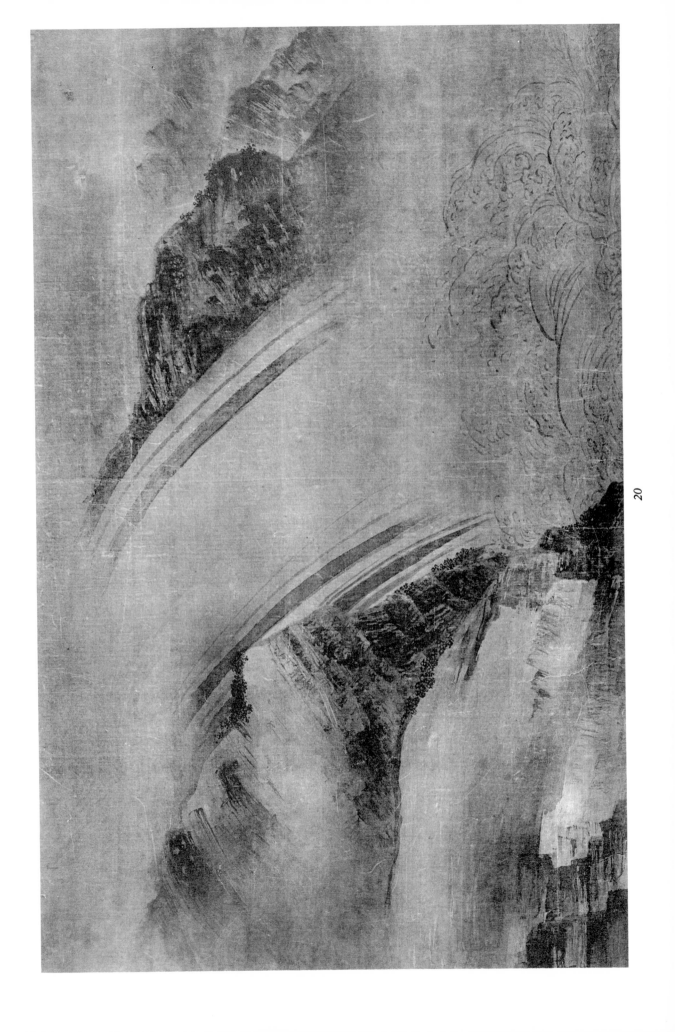

20

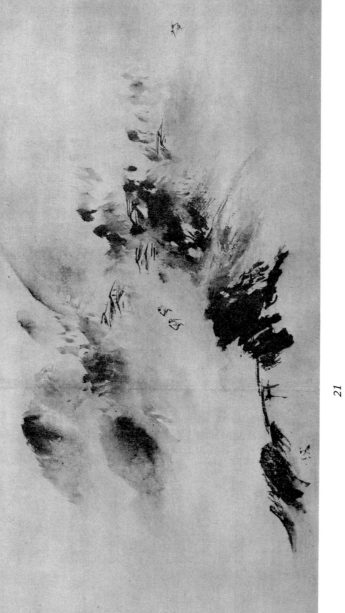

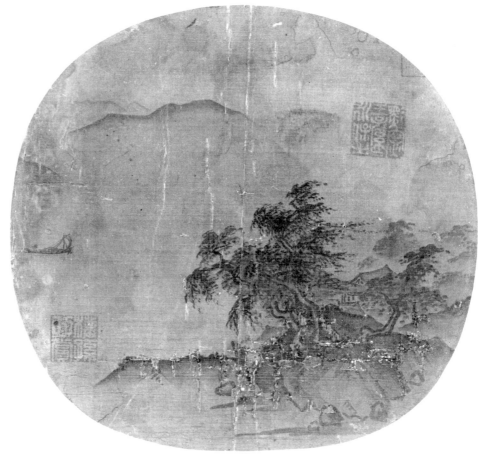

22

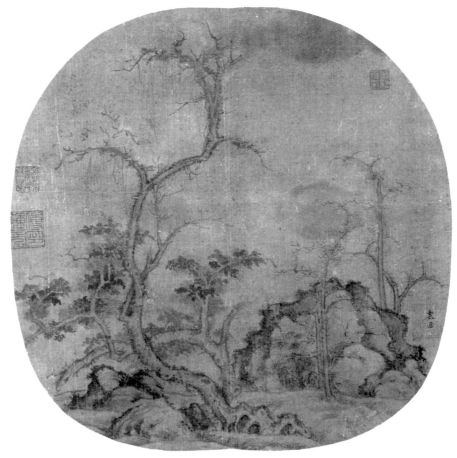

23

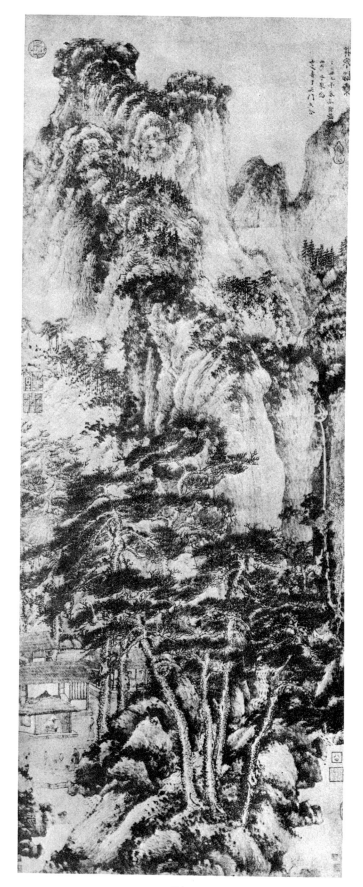

24

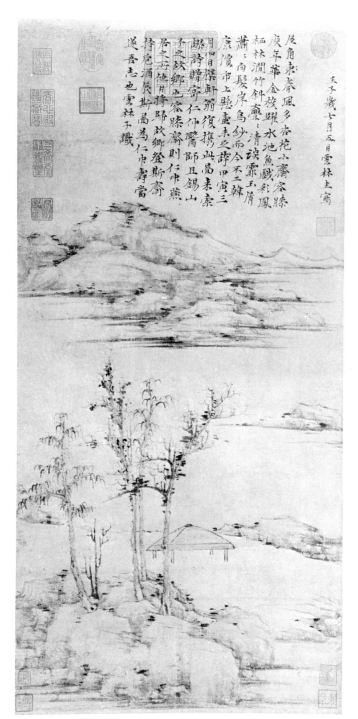

25

明沈石田為孫叔善作幽居圖

真蹟第一品

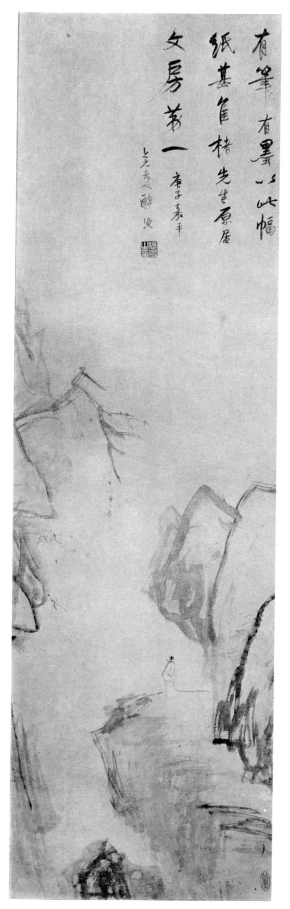

有筆 有墨以此幅
紙墨焦楮先生原屬
文房第一 庚子嘉平
乙元老人醉後

27

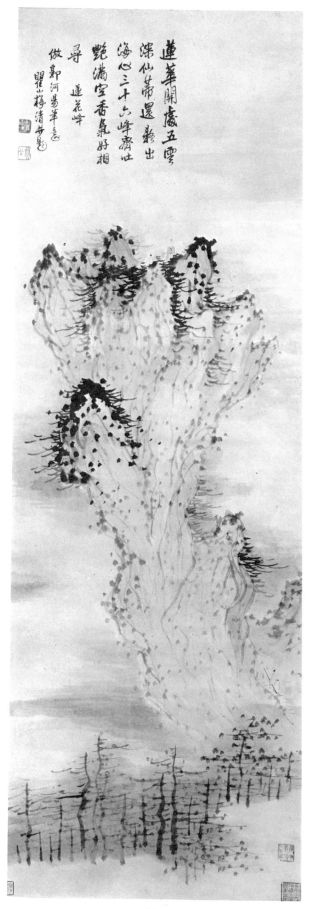

蓮華開處五雲
深仙芽帶還從出
海心三十六峰齊吐
艷滿空香氣好相
尋 蓮花峰
倣郭河陽筆意
瞿山梅清并題

28

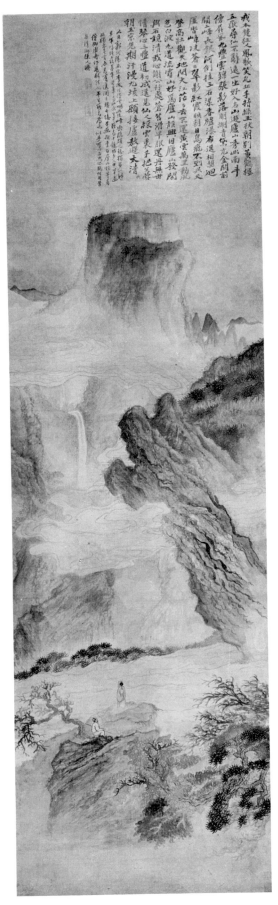

29

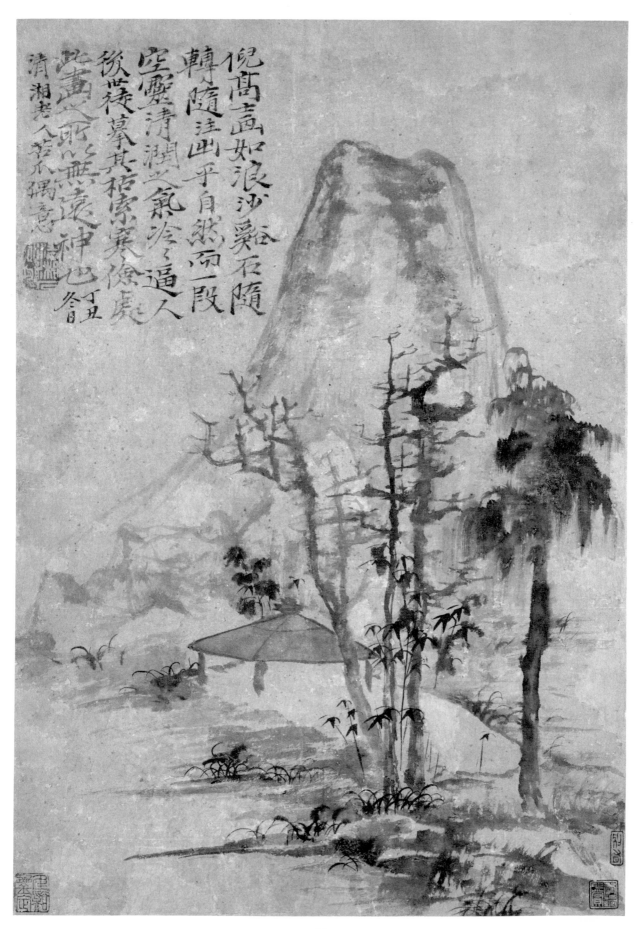

倪高士畫如浪沙谿石隨
轉隨注出自然而一段
空靈清潤之氣冷冷逼人
徐世森摹其枯索寒儉處
此畫以飛以舞以無邊渺神也
清湘老人極不偶意
丁丑冬日

30

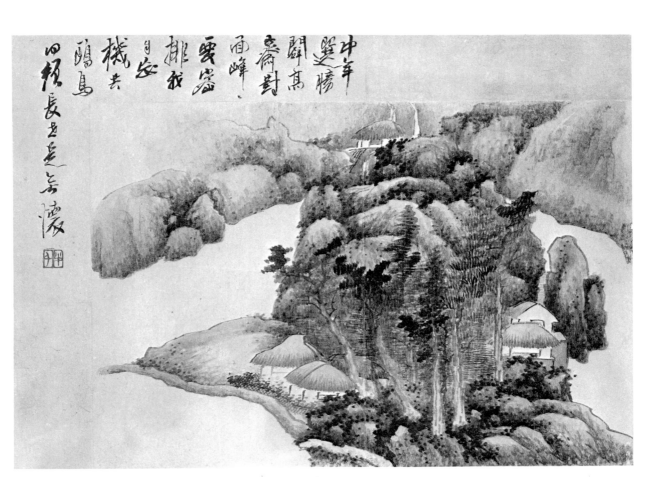

中年愛惜辭高齋對雨峰雲嵓排我機去鷗鳥四顧長是老石濱

31

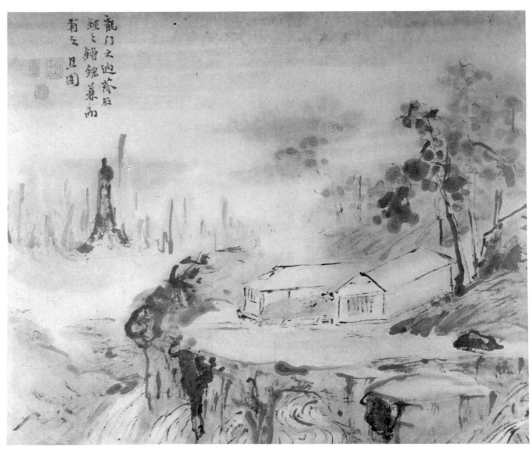

龍門之迤藤右越之鐤鈜兼而有之且囿

32

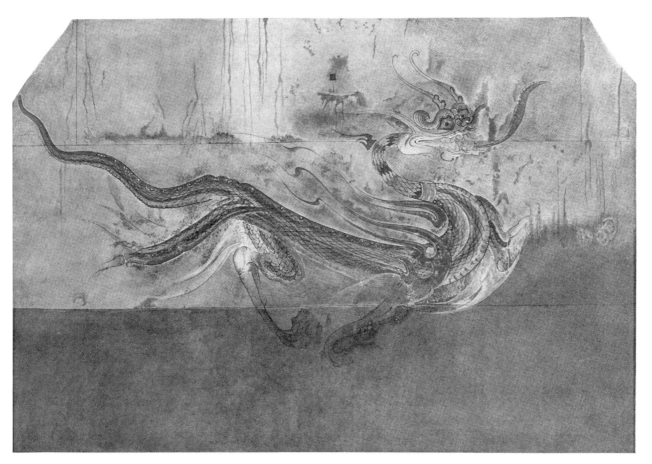

33

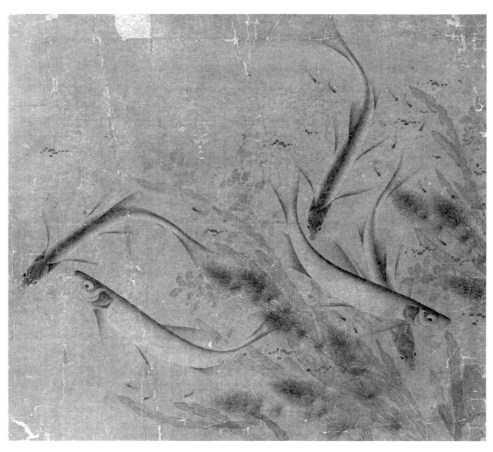

34

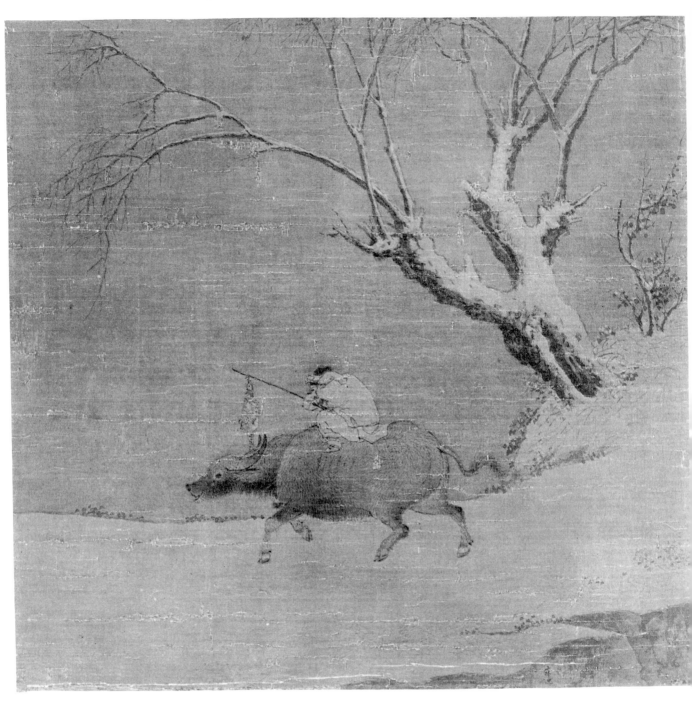

35

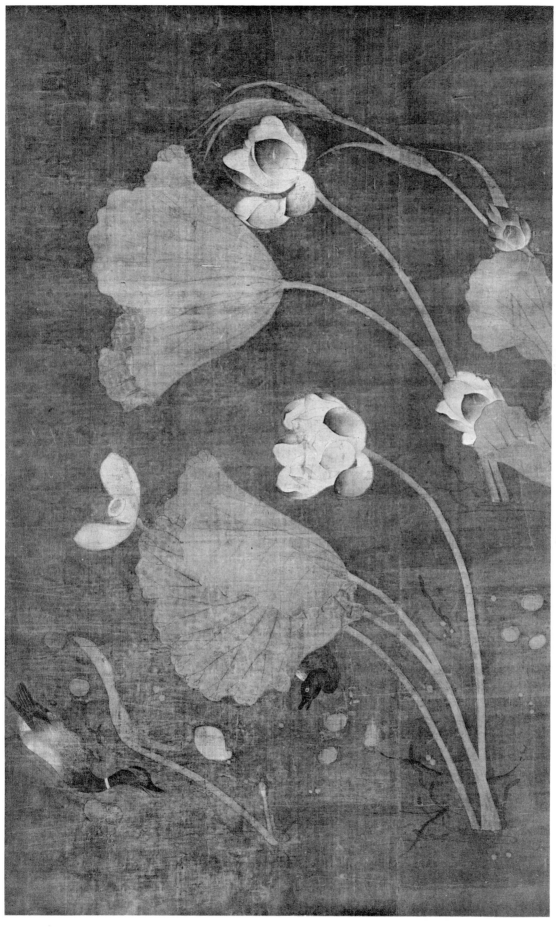

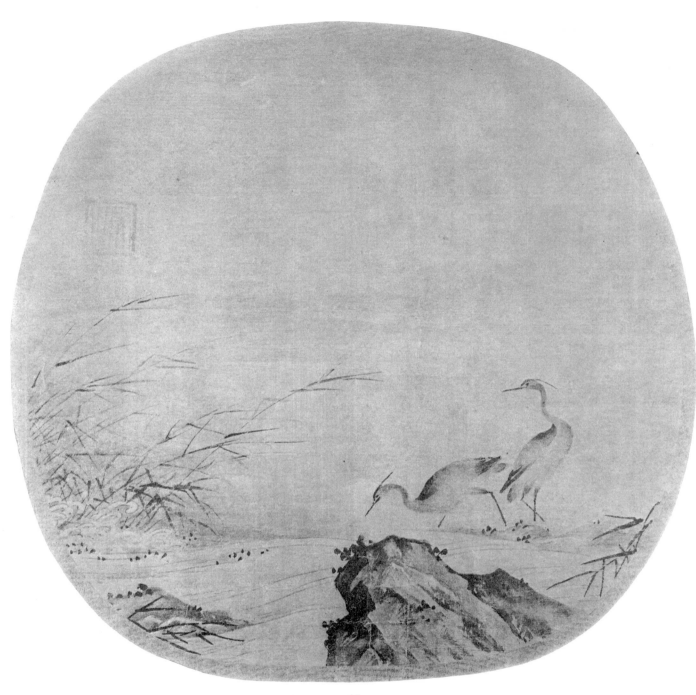

37

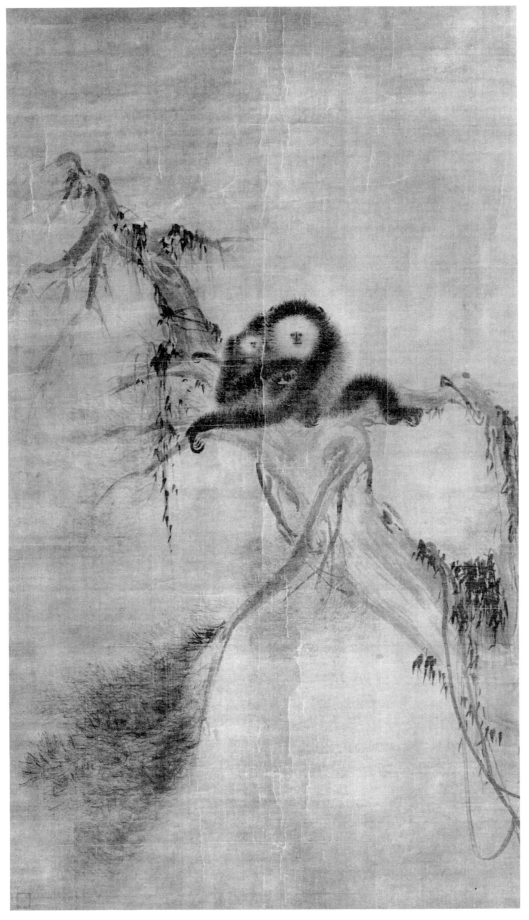

38

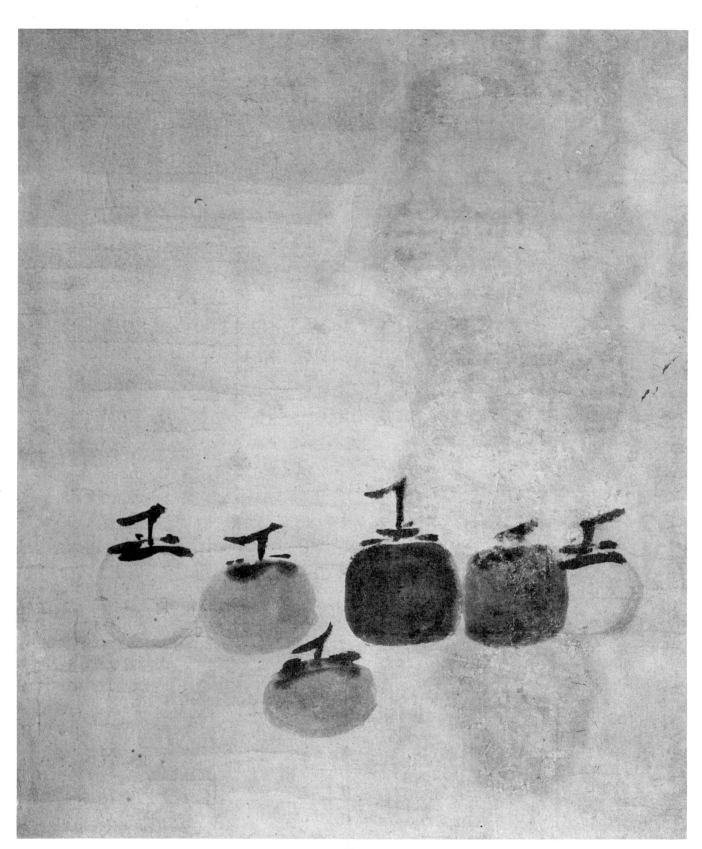

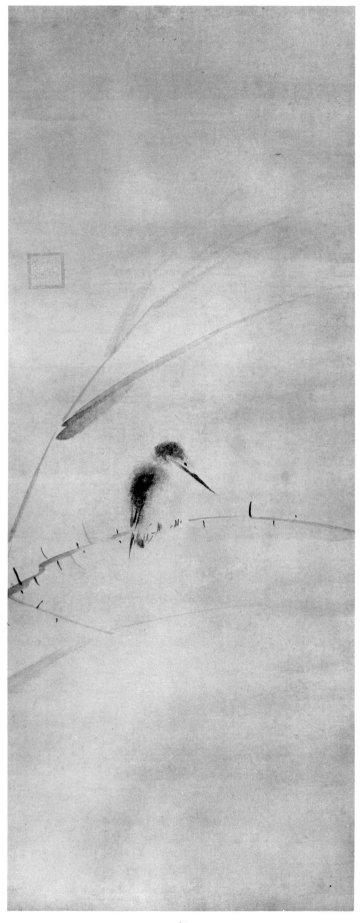

40

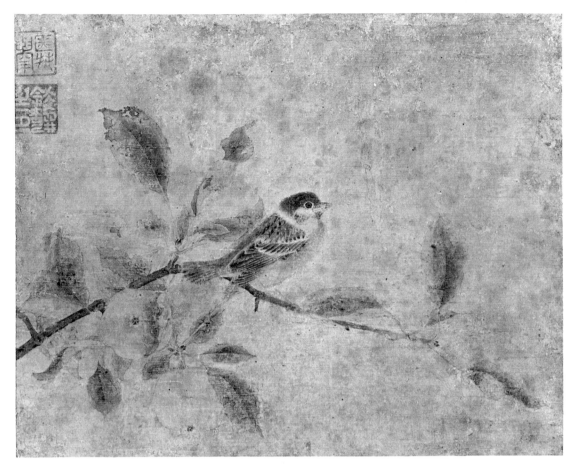

41

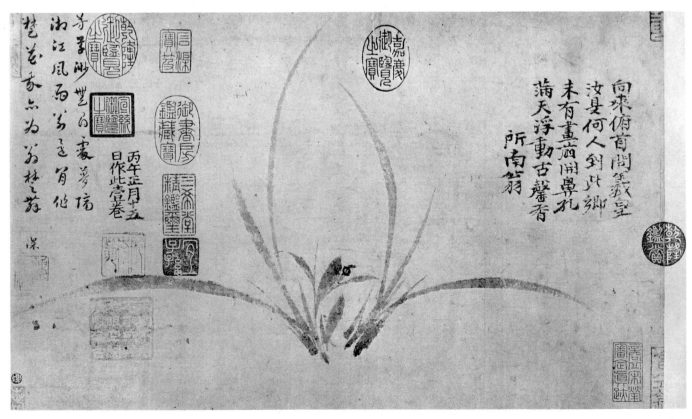

42

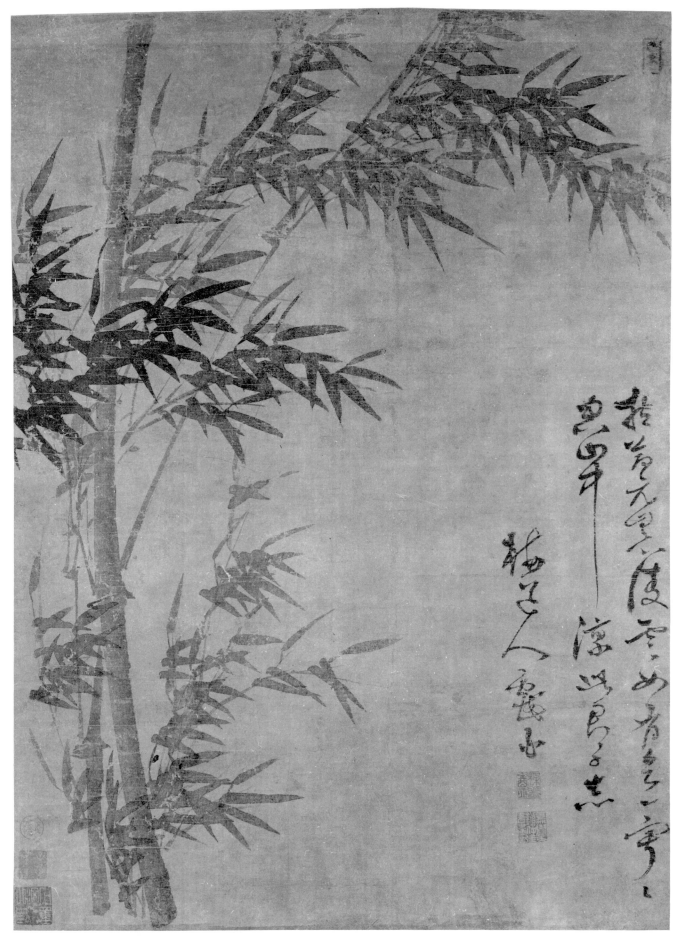

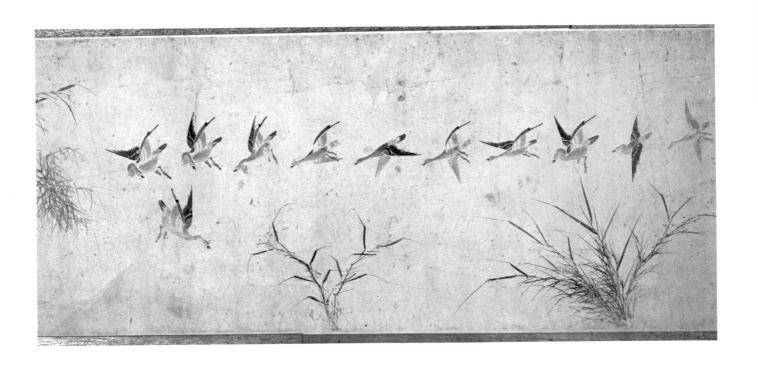

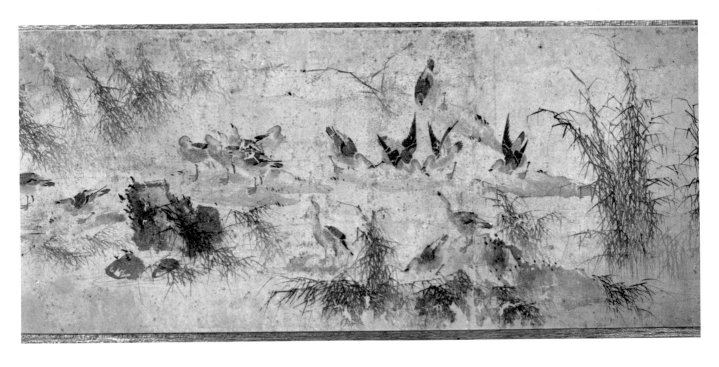

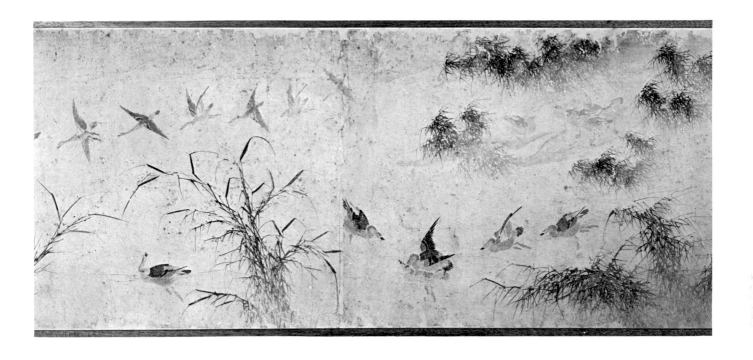

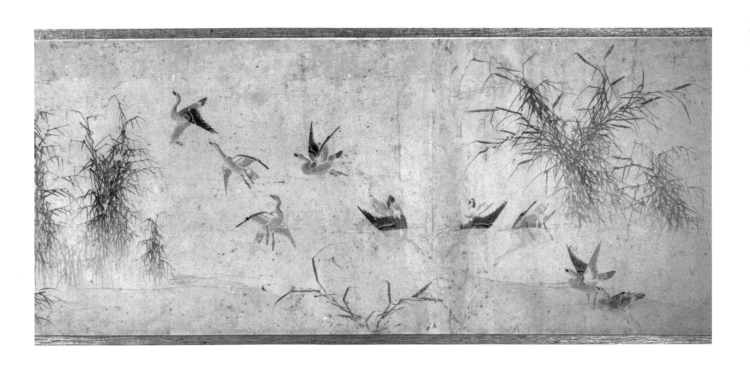

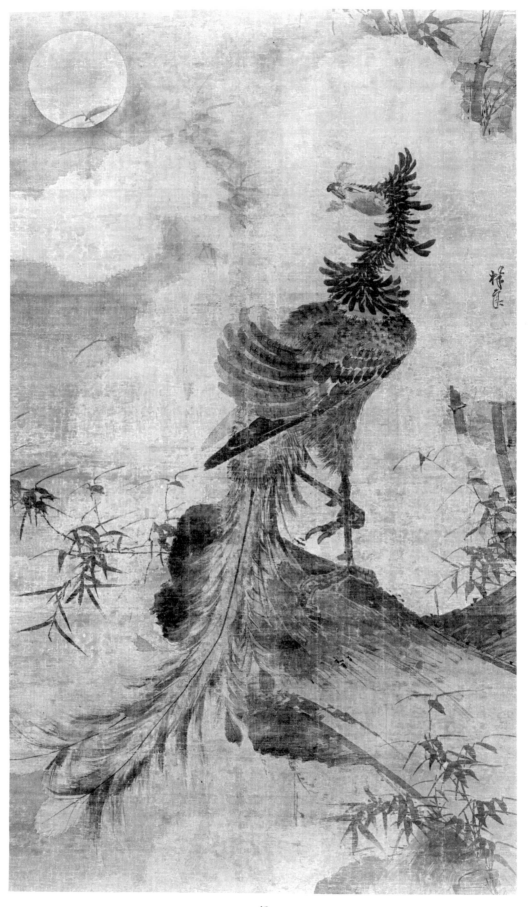

45

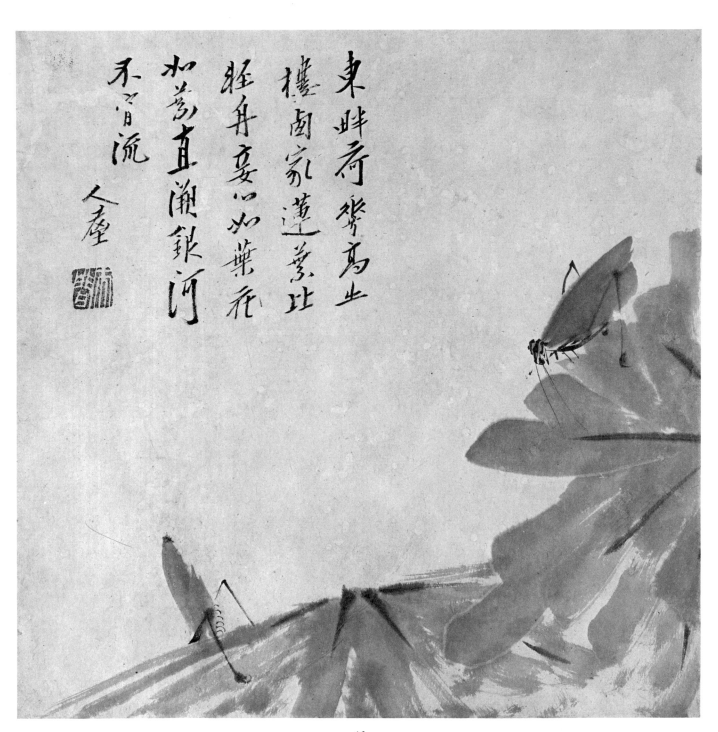

東畔荷聲為業
檣園家蓮菜北
輕舟妾心如葉花
如茲直瀉銀河
不肯流

人產

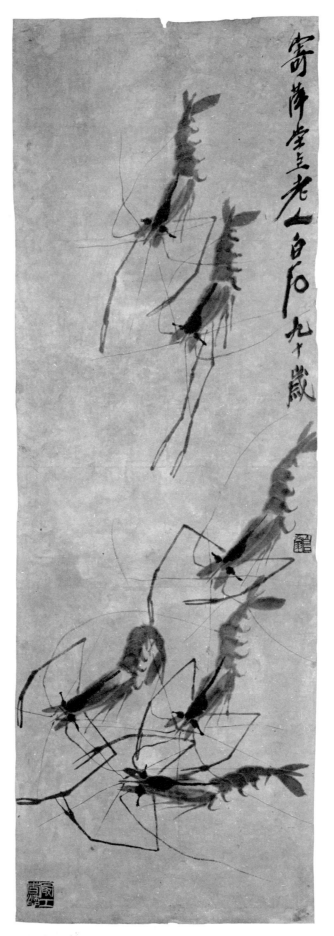

47